HOCKEY
IN
CHARLOTTE

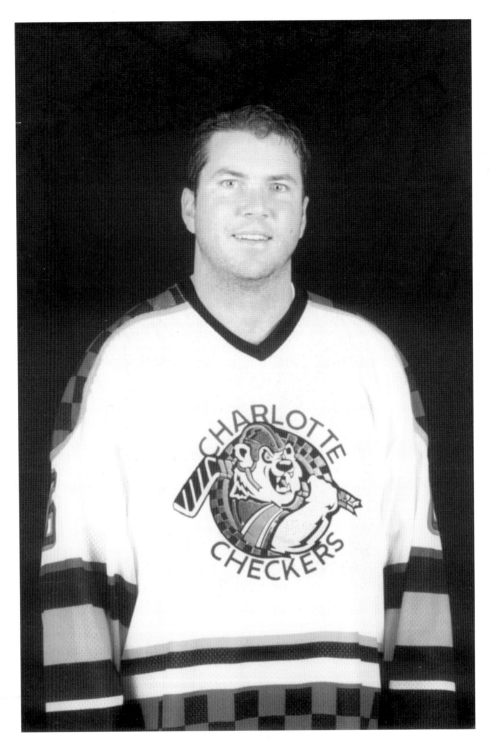

DARRYL NOREN. Here is the all-time leading scorer for the Charlotte Checkers of the East Coast Hockey League (ECHL).

HOCKEY
IN
CHARLOTTE

Jim Mancuso with Pat Kelly

ARCADIA

Published by Arcadia Publishing
Charleston SC, Chicago IL, Portsmouth NH, San Francisco CA

Printed in Great Britain

Library of Congress Catalog Card Number: 2005934389

For all general information contact Arcadia Publishing at:
Telephone 843-853-2070
Fax 843-853-0044
E-mail sales@arcadiapublishing.com
For customer service and orders:
Toll-Free 1-888-313-2665

Visit us on the Internet at www.arcadiapublishing.com

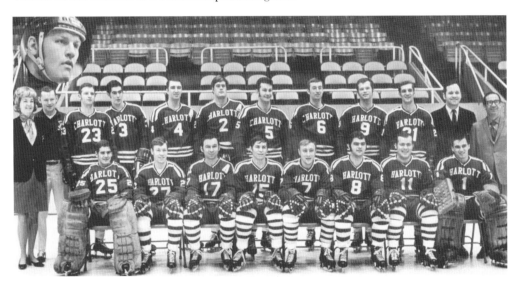

1969–1970 CHARLOTTE CHECKERS. From left to right are (seated) Michel Belhumeur, Jack McCreary, Ernie Dyda, Allie Sutherland, Jack Wells, Neil Clark, Garry Mills, and John Voss; (standing) Janie Van Buren (office manager), Jerry Maloney (trainer), Tom Trevelyan, John Van Horlick, Frank Golembrosky, Bob Shupe, Hal Willis, Barry Burnett, John Gould, Barry Simpson, Fred Creighton (coach), and Al Manch (team president). In the insert is John Rodger.

CONTENTS

Acknowledgments 6

Introduction 7

1. The Birth of Professional Hockey in the South 9

2. Eastern Hockey League Champions 23

3. Hockey Nights in Dixie 45

4. Back-to-Back Walker Cup Crowns 57

5. The Southern Hockey League 75

6. Professional Hockey Returns to Charlotte 101

7. The Winning Tradition in Charlotte Continues 109

8. Patrick J. Kelly: A Hockey Legend 123

ACKNOWLEDGMENTS

The images in this book were courtesy of Ernie Fitzsimmons, the Hockey Hall of Fame in Toronto, and the Charlotte Checkers Hockey Club. Though the photographs were not directly obtained from him, credit is due to Charlotte Checkers (ECHL) photographer Gary Cole, who was responsible for taking some of the photos featured in this publication.

I would like to thank Ernie Fitzsimmons; Craig Campbell, manager of the Hockey Hall of Fame Resource Center and Archives; and Edwin Duane Isenberg for their imaging work on the illustrations in this book.

I was helped directly through the Charlotte Checkers office by team director of communications and promotions Jon Pickett and public relations representative Marilynn Bowler.

The statistics in this book were obtained from the Hockey Hall of Fame Archives in Toronto, Official Eastern Hockey League (EHL) press releases from P. E. M. Thompson (1954–1973), the *1956–1957 Eastern Hockey League Yearbook*, the *1959–1960 Eastern Hockey League Yearbook*, Ralph Slate's Hockey Database (http://www.hockeydb.com), the Society for International Hockey Research, and *Total Hockey (Second Edition)—The Official Encyclopedia of the National Hockey League (NHL)*. Please note that first, official EHL annual statistics were not broken up by team for some seasons; second, the Eastern Hockey League, in existence from 1933 to 1973, was known as the Eastern Amateur Hockey League (EAHL) from 1933 to 1953; and third, the Central Hockey League (CHL), in existence from 1963 to 1984, was known as the Central Professional Hockey League (CPHL) from 1963 to 1968.

Other resources used to complete this work included *The Clinton Comets: An EHL Dynasty*, by Jim Mancuso and Fred Zalatan; John Brophy; Charlotte Checker programs (1956–1977); the *Charlotte Observer* (1956–1977); Pat Kelly; *Hockey In Syracuse* by Jim Mancuso; *The Hockey News* (1947–2005); *The Sporting News Hockey Guide* (1967–1981); Maria Wygand of the *Charlotte Observer*; and Fred Zalatan.

Note that there are two sets of all-time Charlotte franchise leaders—first was the original Charlotte Clippers/Checkers franchise (EHL/SHL) from 1956 to 1977, and second was the ECHL Charlotte Checkers franchise from 1993 to 2005.

A special thanks goes to my mother, Ms. Joan Mancuso, ticket sales representative at the Utica Memorial Auditorium, who got me in free to hockey games in the 1970s and early 1980s.

This book is dedicated in memory of Al Manch, longtime president of the original Charlotte Checkers.

INTRODUCTION

The city of Charlotte is considered to be the birthplace of professional hockey in the South. When the Baltimore Clippers of the Eastern Hockey League (EHL) first used the Charlotte Coliseum as their home rink in January 1956, it was the beginning of the hockey craze below the Mason-Dixon Line. The following season, 1956–1957, the Clippers made Charlotte their permanent home. The Clippers won the EHL's Atlantic City Boardwalk Trophy playoff championship in 1956–1957 and captured back-to-back Walker Cup regular-season league titles during the team's first two campaigns in Charlotte. The team was also a big hit at the box office in the late 1950s, as fans came out in droves to the new game in town.

The Charlotte Clippers, renamed the Checkers in the 1960–1961 season, have the distinction of being the first professional hockey team belonging to an interstate league ever to be based in the Southeast region of the United States. The only other professional hockey teams ever based in the South prior to Charlotte were members of the Tropical Hockey League (TrHL) in 1938–1939. The TrHL was a four-team league that folded after its inaugural season. All four teams in the league—the Coral Gables Seminoles, Havana Tropicals, Miami Clippers, and Miami Beach Pirates—were based in Miami. The TrHL lasted only a 15-game regular season and had no impact on creating interest or spreading the game of hockey in the South.

The success that the Charlotte club experienced both on the ice and at the gate paved the way for new teams and eventually new leagues in the South. The hockey brass took notice of the craze that was taking place over the sport of hockey in the North Carolina city. The EHL added more Southern franchises to the fold; teams in the South started to emerge in the higher minor leagues like the Central Professional Hockey League (CPHL) and the American Hockey League (AHL); and eventually major league hockey went south when the National Hockey League (NHL) and then the World Hockey Association (WHA) expanded there.

Charlotte has also been the most successful Southern city in the history of professional hockey, winning the most playoff championships with six. The city captured three EHL championships in 1956–1957, 1970–1971, and 1971–1972, two Southern Hockey League (SHL) championships in 1974–1975 and 1975–1976, and one East Coast Hockey League (ECHL) championship in 1995–1996.

The former and present-day Checkers franchises have had several outstanding players that have had NHL careers as players or as coaches. These include John Brophy, Eric Cairns, Jacques Caron, Fred Creighton, Bill "Cowboy" Flett, John Gould, Mike Hartman, Pete Horeck, Pat Kelly, Jackie Leclair, Terry Martin, John Muckler, Bob Sauve, Derek Smith, and Gilles Villemure. Flett, Hartman, Leclair, and Muckler are the only players in Charlotte hockey history to have their names on the Stanley Cup. Walter "Turk" Broda, Checker coach in 1963–1964, whose name is also on the Stanley Cup, is the only inductee into the Hockey Hall of Fame with an association to Charlotte hockey.

The present-day Charlotte Checkers are members of the ECHL, which is the premier AA hockey league in North America. The team has been developing future NHL prospects since the 1993–1994 season. The Checkers are currently the number-two farm team of the New York Rangers (NHL) and Ottawa Senators (NHL). The club is also affiliated with the AHL's Hartford Wolf Pack and Binghamton Senators. The Checkers have had great success in the ECHL, winning the league playoff championship in 1995–1996 and making the playoffs eight seasons between 1993 and 2005. Over the years, the team boasted a league MVP, a league scoring champion, several all-stars, and members of the league's all-rookie team.

The Checkers have provided area fans with a high caliber of hockey and have established themselves as one of the top sporting attractions in Charlotte as well as the state of North Carolina. As the Checkers entered their 13th season in 2005–2006, the club is moving into a new home at the Charlotte Arena (seating capacity of 6,500). The Checkers continue to carry on the greatest hockey tradition in the South.

The Birth of Professional Hockey in the South

On January 23, 1956, the Carlin's Iceland in Baltimore burned down, forcing the Eastern Hockey League's Baltimore Clippers to find a place to play their 12 remaining home games. Along with playing some of these games in opposing arenas, the Clippers played five of their remaining home dates in Charlotte, North Carolina, and drew a total of over 40,000 fans. The first game at the 9,500-seat Charlotte Coliseum was scheduled for Monday, January 30, and a traffic jam near the arena arose with over 3,000 people being turned away at the gate. A lucky crowd of 10,363 attended the Baltimore–New Haven Blades match and sang "Dixie" before the opening face-off. There was a write-up of the game in the *Charlotte Observer*, which included a picture of the action.

> The gentlemen you see above are standing on ice. They are wearing skates. They are also wearing padded clothes. Not only that, they're carrying sticks. They're scuffling over a little old disk called a puck. You'd have thought it was the World Series. This game goes great up East and in Canada. This game came to Charlotte last night. The game goes pretty great in Charlotte, too. Thousands of people who didn't know a goalie from a dasher board lined up their cars a mile or so on Independence Boulevard and all the other streets around the Coliseum, trying to get into the place.

The Blades won the match 6-2, a game that was believed to be the birth of professional hockey in the South. The Clippers moved to Charlotte permanently the next season (1956–1957), and they were renamed the Charlotte Clippers. The Eastern Hockey League (EHL) would add a half-dozen more franchises in the South over the next 15 years because of the success experienced in Charlotte. The EHL was considered to be a professional league because players were paid a salary, but players were classified as amateurs.

The Charlotte Clippers' success had EHL brass planning on expanding the league in the South, as the loop added a South Division in 1959–1960 and granted a franchise to nearby Greensboro that season. The EHL's Jersey Larks operation lasted only its first campaign in 1960–1961, and the franchise relocated to Knoxville, Tennessee, the following season in response to the growing hockey interest in the South. The league added franchises in Nashville, Tennessee, in 1962–1963; Jacksonville, Florida, in 1964–1965; Salem, Virginia, in 1967–1968; and St. Petersburg, Florida, in 1971–1972.

The hockey boom in the South led to other circuits adding teams in Dixie. The CPHL put teams in Memphis and Houston in 1965–1966 and Dallas in 1967–1968. The AHL established teams in Tidewater, Virginia, in 1971–1972 and Jacksonville and Richmond in 1972–1973. The NHL even followed suit by putting an expansion team in Atlanta in 1972–1973.

In 1973–1974, the first interstate professional hockey league based entirely in the South, the Southern Hockey League (SHL), was formed as a result of the seeds that were planted in Charlotte less than two decades before. The loop forged new markets in Macon, Georgia, and Winston-Salem, North Carolina.

Since the birth of the original Charlotte franchise almost two decades after the TrHL ceased operations, there have been over 100 professional hockey franchises established in the South, including seven National Hockey League (NHL) teams—the Atlanta Flames, Atlanta Thrashers, Carolina Hurricanes, Dallas Stars, Florida Panthers, Nashville Predators, and Tampa Bay Lightning. There have also been five professional hockey leagues that existed solely in the South since the original Checkers first took to the ice. These included the Southern Hockey League (SHL) from 1973 to 1977, the Atlantic Coast Hockey League (ACHL) in 2002–2003, the South East Hockey League (SEHL) in 2003–2004, the World Hockey Association 2 (WHA2) in 2003–2004, and the Southern Professional Hockey League (SPHL) from 2004–2005 to the present. Three professional leagues also formed that included Southern cities: the All-American Hockey League (AAHL) in 1987–1988, the Atlantic Coast Hockey League (ACHL) from 1981 to 1987, and the East Coast Hockey League (ECHL) from 1988–1989 to the present.

1938–1939 TROPICAL HOCKEY LEAGUE
PROGRAM. The Tropical Hockey League
published two different programs during
its 1938–1939 season. Both programs had
identical covers, but one program had the
line-ups of the Coral Gables Seminoles and
Havana Tropicals, and the other program
had the line-ups for the Miami Clippers and
Miami Beach Pirates.

Inaugural Year

**SOUTHERN HOCKEY
LEAGUE**

Directory
&
Schedule
1995-1996

1995–1996 SOUTHERN HOCKEY LEAGUE
MEDIA GUIDE. The Southern Hockey
League name was revived in a new league
that lasted only one season in 1995–1996.
Four of the six teams in the league were
located in Florida: the Daytona Breakers,
Jacksonville Bullets, Lakeland Prowlers
(regular season champions), and West Palm
Beach Barracudas. The two non-Florida
teams, the Channel Cats from Huntsville,
Alabama, and the Mammoths from
Winston-Salem, North Carolina, faced off
in the league playoff finals, with Huntsville
winning the league championship. The
league championship trophy was actually a
milk can.

MACON WHOOPEES '73

1973–1974 MACON WHOOPEES PROGRAM. The Macon Whoopees were inaugural members of the SHL in 1973–1974 and were the first minor-league professional hockey team in the state of Georgia. The Whoopees did not last a full season, as they folded in February 1974. After a 23-year hiatus, professional hockey returned to Macon in 1996–1997 with a Central Hockey League (CHL) version of the Whoopees.

2001–2002 LOUISIANA ICEGATORS MEDIA GUIDE. The Louisiana IceGators were members of the ECHL for 10 seasons, playing their last season in 2003–2004. They have always made the league playoffs and played in the Kelly Cup finals twice (1996–1997 and 1999–2000). Louisiana coach Dave Farrish won the ECHL's Coach of the Year Award in 2001–2002. Prior to the 2003–2004 season, the award was renamed the John Brophy Award.

LOUISIANA ICEGATORS
2001-2002 MEDIA GUIDE

MEMBER OF THE EAST COAST HOCKEY LEAGUE

THE BIRTH OF PROFESSIONAL HOCKEY IN THE SOUTH

1970–1971 NASHVILLE DIXIE FLYERS. The 1970–1971 season was the last season for the Nashville Dixie Flyers, who played nine seasons in the EHL (1962–1971). The Dixie Flyers won two EHL playoff championships, two regular season championships, and three South Division titles. In 1964–1965, Nashville set new EHL all-time regular-season marks for wins (54) and points (108) with a 54-18-0 record.

1968–1969 MEMPHIS SOUTH STARS PROGRAM. The Memphis South Stars played five seasons (1964–1969) in the CPHL/CHL. The club was known as the Memphis Wings from 1964 to 1967, when the team was affiliated with Detroit (NHL). When Memphis switched its NHL affiliation to the expansion Minnesota North Stars in 1967–1968, the Southern city changed its name to South Stars.

1999–2000 ORLANDO SOLAR BEARS. The Solar Bears played six seasons in the International Hockey League (IHL) from 1995 to 2001. The Orlando Solar Bears have the distinction of being the last team to win the Turner Cup in 2000–2001, since the IHL folded after that season.

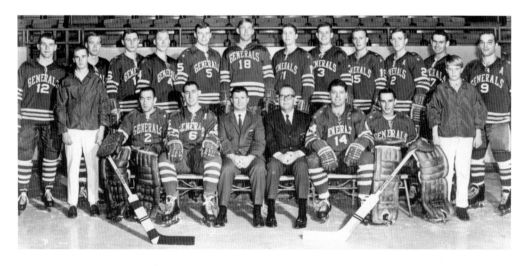

1967–1968 GREENSBORO GENERALS. From left to right are (first row) Bob Smith (trainer), Ron Muir, Ron Spong (coach), Stanley Frank (general manager/vice president), Don Carter, and John Voss; (second row) Stu Roberts, unidentified, Moe L'Abbe, Rick Morris, Doug Carpenter, Roger Wilson, Bill Adair, Bill Young, Barry Salovaara, Don Burgess, John Murray, Bob Sackinski, unidentified, and Dom DiBerardino.

THE SUNSHINE HOCKEY LEAGUE. The Sunshine Hockey League (SuHL) was the first professional hockey league based entirely in Florida since the Tropical Hockey League in 1938–1939. The SuHL lasted three seasons, from the 1992–1993 season to the 1994–1995 season, and had a total of six franchises in its history. The league had five teams during its inaugural year: the Daytona Sun Devils, Jacksonville Bullets, Lakeland Ice Warriors, St. Petersburg Renegades, and West Palm Beach Blaze. St. Petersburg folded prior to the second campaign, and the league operated with four teams. In its final season, the circuit added a fifth team in California—the Fresno Falcons. The championship trophy of the SuHL was the Sunshine Trophy, which was won by West Palm Beach in all three seasons.

Inaugural Season

WEST PALM BEACH BARRACUDAS 1995-1996

MEDIA GUIDE

1995–1996 WEST PALM BEACH BARRACUDAS PROGRAM. The Barracudas were members of the Southern Hockey League (SHL) in the club's and the league's only season of existence. West Palm Beach finished fifth in the SHL with a 26-34 record. Angelo Russo was the team's leading point (65) and goal scorer (36). Todd Bojcun was the club's leading goaltender, compiling a 4.48 goals against average (GAA) and a 23-23-1 record in 48 games.

1992–1993 ST. PETERSBURG RENEGADES PROGRAM. The Renegades were inaugural members of the Sunshine Hockey League (SuHL) and were St. Petersburg's first professional hockey team since the Suncoast Suns. The Suns played in the Eastern Hockey League from 1971 to 1973 and then folded midway through the Southern Hockey League's inaugural season in 1973–1974.

INAUGURAL ISSUE

WEST PALM BEACH BLAZE. West Palm Beach was the greatest team in the three-year history of the Sunshine Hockey League (SuHL). The Blaze won all three Sunshine Trophy championships from the 1992–1993 season to the 1994–1995 season, won all three regular-season titles, and compiled the best all-time regular-season winning percentage in SuHL history—.724 with a 113-43 record. U.S. Hockey Hall of Fame inductee Bill Nyrop (1997) was the coach and owner of West Palm Beach during all three seasons.

THE DAYTONA BEACH SUN DEVILS. The Sun Devils were members of the SuHL during the league's three seasons of existence. Daytona had an overall record of 52-106 (.329) and finished in last place two of its three seasons. Offensive stars for the Sun Devils included Mike Kelly (104 points and 48 goals in 96 games from 1992 to 1995) and Dale Kelly (102 points and 71 assists in 141 games from 1992 to 1995). Joel Clark starred in goal for three seasons with Daytona and compiled a 5.77 GAA and a 19-24-2 record in 55 games.

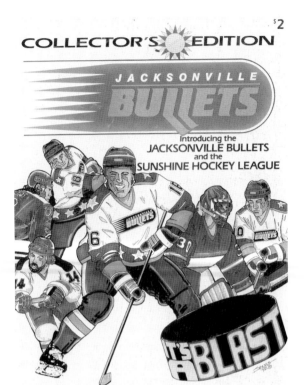

JACKSONVILLE BULLETS PROGRAMS. The Jacksonville Bullets played in all three seasons of the Sunshine Hockey League (SuHL) from 1992–1993 to 1994–1995 and the one season of the revived Southern Hockey League in 1995–1996. Jacksonville had an overall record of 110-108 (.505) during the club's four seasons of existence. The Bullets made it to the Sunshine Trophy finals in all three SuHL seasons, but were swept three games to none each year by West Palm Beach.

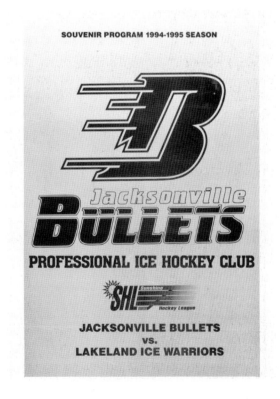

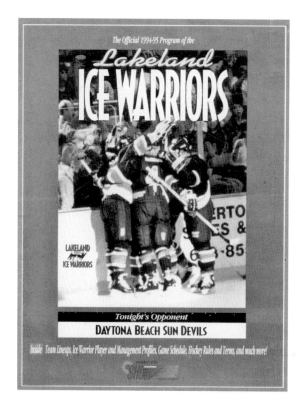

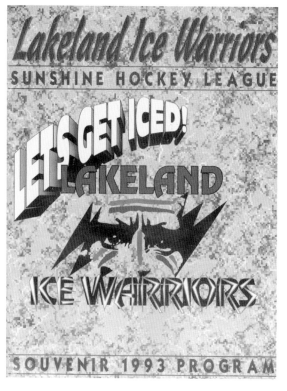

LAKELAND ICE WARRIORS. The Ice
Warriors compiled a 64-98 (.395)
record during the club's three seasons
in the Sunshine Hockey League.
Offensive stars for the Ice Warriors
were Derek Edgerly (180 points and 87
goals in 143 games from 1992 to 1995),
Bob Nicholls (165 points and 99 assists
in 107 games from 1993 to 1995), and
Francois Michaud (98 points and 67
goals in 128 games from 1992 to 1995).
John Finnie was between the pipes in
more games than any other Lakeland
net minder, compiling a 4.96 GAA and
a 33-36-3 record in 82 contests from
1993 to 1995.

THE BIRTH OF PROFESSIONAL HOCKEY IN THE SOUTH

1995–1996 JACKSONVILLE BULLETS
PROGRAM. After experiencing success
for three seasons in the Sunshine
Hockey League, Jacksonville had
its first dismal season in the new
Southern Hockey League (SHL) in
1995–1996. The Bullets finished in last
place out of six teams in the SHL with
a 23-37 record, and the club folded
after that season.

1994–1995 WEST PALM BEACH BLAZE MEDIA
GUIDE. The Blaze are one of the few teams
in professional hockey history to win three
consecutive playoff championships. Only seven
minor-league professional teams have ever
accomplished that feat. The Shreveport (later
Bossier-Shreveport) Mudbugs of the Western
Professional Hockey League (WPHL) were
the eighth and last team to win three straight
postseason championships, from 1998–1999 to
2000–2001.

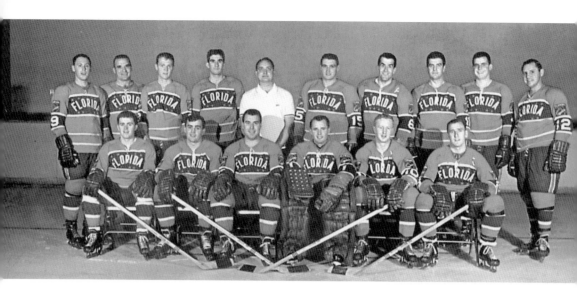

1967–1968 FLORIDA ROCKETS. From left to right are (first row) Jack Smith, Joe Marich, Bob Sabourin (coach), Harrison Gray, Ron Willy, and Harold White; (second row) Billy Glashan, Alf Treen, Les Colligan, Carson Ryan, Joe Woitowich (trainer), Jim Lorette, Mark Brunet, Jackie Leclair, Gerry Lemire, and Cummy Burton.

2

EASTERN HOCKEY

LEAGUE CHAMPIONS

The Charlotte Clippers were very successful both on and off the ice in their debut season in 1956–1957. The team was stocked with prolific scorers under coach Andy Brown. Six of the EHL's top 10 scorers that season were from Charlotte—Al O'Hearn (first with 117 points), Doug Adam (second with 114 points), Chuck Stuart (third with 108 points), Stan Warecki (sixth with 103 points), Herve Lalonde (seventh with 97 points), and Jim McNulty (10th with 91 points). Les Binkley placed second in EHL goaltending (3.79 GAA). O'Hearn's 117 points and Adam's 65 goals are Clippers/Checkers (EHL/SHL) all-time single-season records. The defense was led by John Brophy and John Muckler. The Clippers had four players named to the EHL all-star team—Adam (right wing) was named to the first team and Binkley (goalie), Muckler (defense), and O'Hearn (right wing) were named to the second team.

At the Charlotte Coliseum, crowds averaged over 4,000 per game, and the franchise attendance was 182,487 in the first season of operation. The Clippers shattered the EHL regular season point mark with 101 (nine better than the old record set by the Washington Eagles in 1940–1941). Charlotte was awarded the Walker Cup for winning the regular-season title with a 50-13-1 record. In the postseason, the Clippers defeated the New Haven Blades in the semifinals in six games and then captured the Atlantic City Boardwalk Trophy championship by beating the Philadelphia Ramblers in a seven-game thriller in the finals. The Clippers became the first professional hockey team in the South to win a league playoff championship.

The Clippers repeated as regular-season champions (38-25-1) in 1957–1958 and were awarded the Walker Cup once again. Stan Warecki started the campaign as player/coach but resigned as coach midseason. Warecki remained as a player. Andy Brown, former Clipper coach and current manager of the team, took over the bench once again.

Charlotte defeated New Haven in the semifinals in seven games but was one game short of repeating as playoff champions, as they lost to the Washington Presidents in the finals four games to three. First-team all-star right-wing Doug Adam (fifth with 77 points), Chuck Stuart (sixth with 74 points), and Herve Lalonde (ninth with 67 points) placed in the league's top 10 in scoring. Stuart (center) and John Muckler (defense) were named second-team all-stars. The EHL held an all-star game against the International Hockey League (IHL) in Philadelphia on January 23, 1958. Adam, Jim McNulty, and Stan Warecki were invited to join the EHL squad. The IHL won the match 5-4.

Andy Brown stayed on as coach in 1958–1959, but the club finished in last place out of six teams with a 24-38-2 record. Newcomer Gordon Tottle (defense) was the only Clipper player to make the EHL all-star team, being named to the first squad.

The EHL had an eight-team, two-division format for the 1959–1960 season. Charlotte was placed in the South Division with the expansion Greensboro Generals, the Washington Presidents, and the Johnstown Jets. The Clippers bounced back under new coach Pete Horeck (who also appeared in 15 games) with a second-place finish and a 31-29-4 record. The locals swept Greensboro in the quarterfinals in three games, but were eliminated two games to one in the semifinals by New Haven. Tottle (defense) again made the EHL first-team all-stars.

In 1960–1961, the Charlotte franchise came under new ownership and changed its nickname to the Charlotte Checkers. Gordon Tottle was named player/coach of the team. The Checkers finished in last place in their division with a 25-34-5 record. The following season, the team fared no better under new general manager and coach Joe Crozier with a second consecutive last-place divisional finish (26-40-2). Florent Pilote (defense) was named an EHL first-team all-star and Maurice "Moe" Savard placed 10th in EHL scoring with 92 points.

A postseason berth was earned for the first time in three seasons with a third-place South Division finish with a 35-31-2 record in 1962–1963. The Checkers defeated the Knoxville Knights in the quarterfinals three games to two and lost to Greensboro in the semifinal round three games to two.

A last-place divisional finish (30-41-1) did not impede a playoff spot for Charlotte in 1963–1964, since eight of the nine EHL teams made the postseason. The locals had an early exit in the playoffs, however, as Greensboro swept the Checkers in three games in the quarterfinals. Future hockey hall-of-famer Walter "Turk" Broda was behind the bench for Charlotte that season. Moe Savard, who is the Checkers' all-time leader in assists (452), finished fourth in EHL scoring with 110 points. Jim McNulty was selected to an EHL all-star team that played in the Soviet Union in January 1964.

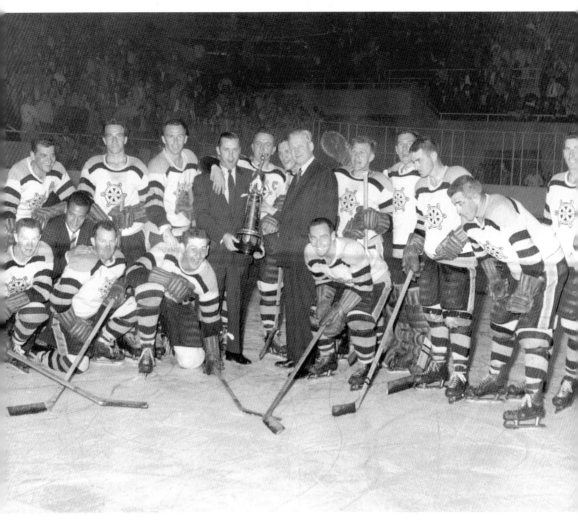

1956–1957 EHL CHAMPIONS. From left to right are (crouching) Ken Murphy, Ray Lacroix, Russ Hann, John Muckler, and Gerry Sullivan; (standing) Stan Warecki, Herve Lalonde, Bill Sinnett, Andy Brown (coach), Albert O'Hearn, Yvan Houle, Thomas Lockhart (EHL president), Fred Weaver, Les Binkley, Jim McNulty, John Brophy, and Doug Adam.

JIM MCNULTY (CENTER). McNulty is the all-time franchise leader in points (775), goals (346), games played (620), and seasons (11). He also accumulated the second most assists (429) during his years with Charlotte from 1956 to 1967. The center ranks eighth all-time in goals in EHL history (361). He played in the EHL–IHL all-star game of 1957–1958 and was selected to the EHL all-star team that played against the Soviet Union in January 1964. McNulty was a member of the Clippers franchise in its inaugural season in Baltimore (1954–1955).

Doug Adam (Left Wing). He played two seasons with Charlotte (1956–1958) and had 191 points and 109 goals in 118 games. Adam was a member of the Clippers' 1956–1957 Atlantic City Boardwalk Trophy championship team. The left winger went on to coach in the EHL with Philadelphia (1958–1961) and in the AHL with Rochester (1971–1972). He had a stint in the NHL with the Rangers in 1949–1950.

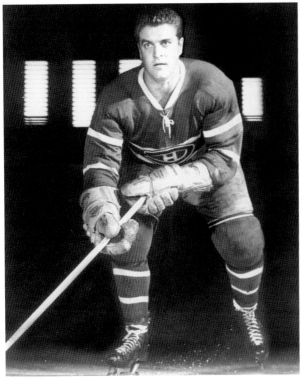

Jackie Leclair (Center). He won two Stanley Cups with Montreal (1955–1956 and 1956–1957). In his three seasons in the NHL (1954–1957), he had 60 points and 40 assists in 160 games. During his time with Charlotte (1962–1964), he garnered 181 points, 123 assists, and 66 PIM (penalties in minutes) in 124 games. The center also skated in the EHL with Florida, Knoxville, and New Haven.

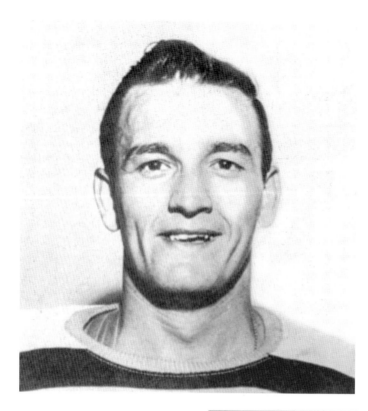

YVAN HOULE (RIGHT WING). Houle played with Charlotte for five seasons (1956–1959, 1960–1961, and 1963–1964), and produced 142 points, 90 assists, and 73 PIM in 151 games. He was a member of the 1956–1957 Atlantic City Boardwalk Trophy championship team. Houle also skated in the EHL with New York and Philadelphia in 1959–1960.

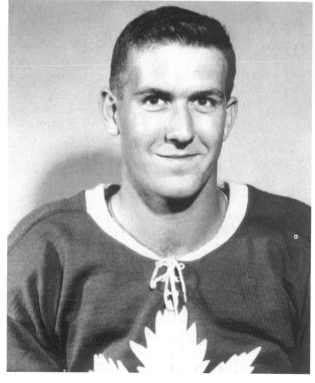

JACK MARTIN (CENTER). Martin had 65 points, 32 goals, and 57 PIM in 67 games with Charlotte in 1962–1963. He played with Nashville (1963–1964) and Knoxville (1964–1965) over the next two seasons. The center had a stint in the NHL in 1960–1961 and also spent time in the Eastern Professional Hockey League (EPHL) from 1959 to 1962, the AHL in 1961–1962, and the Western Hockey League (WHL) in 1961–1962.

DON HOGAN (RIGHT WING). In his only
season in Charlotte (1962–1963), Hogan
had 41 points, 25 assists, and 10 PIM in 52
games. He played two other seasons in the
EAHL/EHL (1951–1952 and 1964–1965).
Before coming to the Checkers, the
right winger skated in the AHL for five
seasons (1955–1956 and 1957–1961) with
Cleveland and Quebec. Hogan also spent
time in the EPHL (1960–1961) and WHL
(1961–1962).

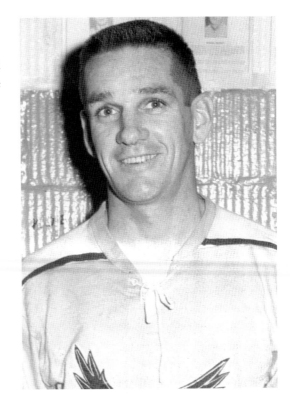

VERN "WIMPY" JONES
(RIGHT WING).
"Wimpy" played
three seasons with
Charlotte (1958–
1961) and had 188
points, 92 goals, and
96 PIM in 186 games.
He also skated in the
EAHL/EHL for seven
other seasons between
1942 and 1962 with
Boston, New Haven,
Philadelphia, and
Springfield. The
right winger was a
member of Calder
Cup–winning Buffalo
(AHL) in 1943–1944.

JOHN MUCKLER (DEFENSE). He was a member of Charlotte's 1956–1957 Atlantic City Boardwalk Trophy championship team. During his three seasons with the Clippers (1956–1959), the defenseman had 128 points, 103 assists, and 241 PIM in 187 games. Muckler coached in the NHL between 1968 and 2000 with Buffalo, Edmonton, Minnesota, and the Rangers. He compiled a 276-288-84 NHL regular-season coaching record and won a Stanley Cup with Edmonton in 1989–1990. Muckler got his coaching start with Long Island (EHL) in 1964–1965, and he guided his team to a playoff championship. He also coached in the AHL and Central Hockey League (CHL) and was awarded coach of the year honors in both leagues—in the AHL (1974–1975), he won the Louis A. R. Pieri Memorial Award with Providence and in the CHL (1978–1979), the Jake Milford Trophy with Dallas. Muckler piloted Dallas (CHL) to an Adams Cup championship in 1978–1979.

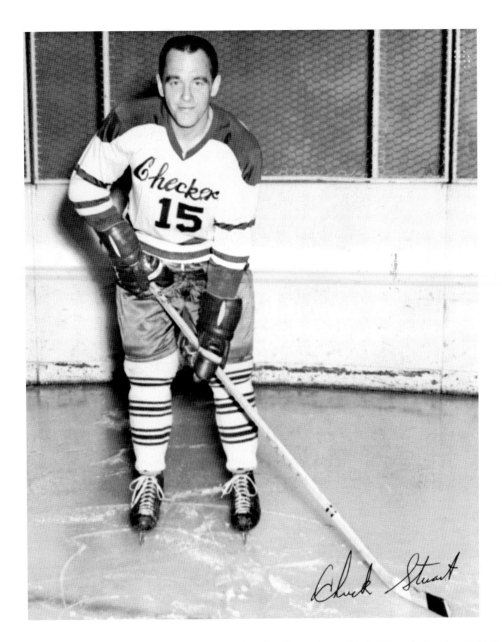

CHUCK STUART (CENTER). Stuart is second all time in EHL history in points (1,121) and goals (513) and sixth all time in assists (608). He established the professional single-season goal mark with 78 in 1962–1963 while playing for Philadelphia (EHL). The record was tied by Alain Caron in the 1975–1976 season while skating in the North American Hockey League (NAHL) and broken by Dave Staffen, who tallied 87 goals in the NAHL in 1976–1977. Stuart played six seasons with Charlotte (1956–1959 and 1966–1969) and was a member of the Clippers' 1956–1957 playoff championship team. He also spent time in the EHL with Johnstown, Knoxville, and Philadelphia and was selected to three EHL all-star teams.

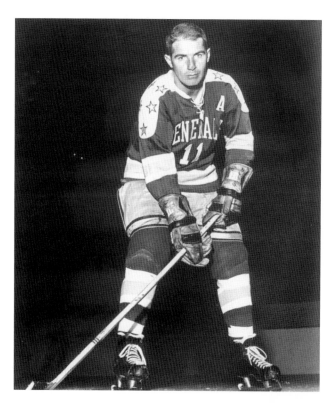

DON DAVIDSON (CENTER). Davidson ranks in the all-time EHL top 10 in all three offensive categories—fifth in points (936), seventh in assists (590), and ninth in goals (346). He was a member of three EHL playoff championship teams—Greensboro in 1962–1963 and Clinton, New York, in 1967–1968 and 1969–1970. In 1957–1958, the center had seven points and five goals in 24 games with Charlotte. He was named an EHL all-star five times.

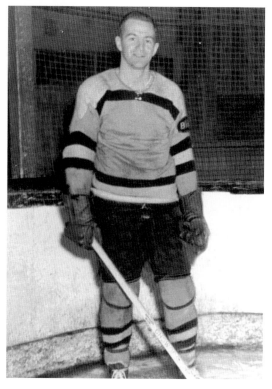

BILL SINNETT (RIGHT WING). The right winger produced 225 points, 148 assists, and 303 PIM in 263 games during five seasons with Charlotte (1956–1961). His last season in the EHL was with Greensboro (1962–1963). Sinnett played six years in the IHL (1952–1953 and 1962–1967) and won a Turner Cup with Cincinnati (1952–1953). He also spent time in the Quebec Hockey League (QHL) in 1951–1952 and 1954–1955 and the WHL in 1953–1954.

PETE TAILLEFER (DEFENSE). In his four seasons in Charlotte (1958–1962), he had 58 points, 49 assists, and 98 PIM in 166 games. Taillefer also played in the Eastern League with Baltimore (1946–1947). The defenseman spent five seasons in the Pacific Coast Hockey League (PCHL) from 1947 to 1952, seven seasons in the QHL from 1952 to 1959, and one season in the IHL in 1961–1962.

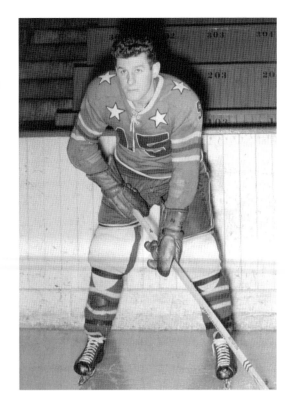

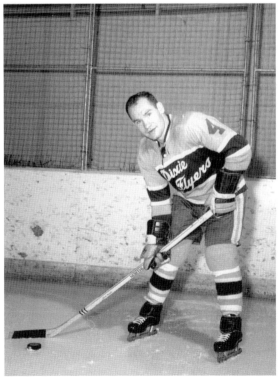

FLORENT PILOTE (DEFENSE). Pilote skated three seasons with Charlotte (1959–1962) and had 106 points, 83 assists, and 204 PIM in 194 games. The defenseman played eight more seasons in the EHL with Nashville (1962–1969) and New Haven (1969–1970) and was a member of two playoff championship teams with the Dixie Flyers (1965–1966 and 1966–1967). He was named to three EHL all-star teams.

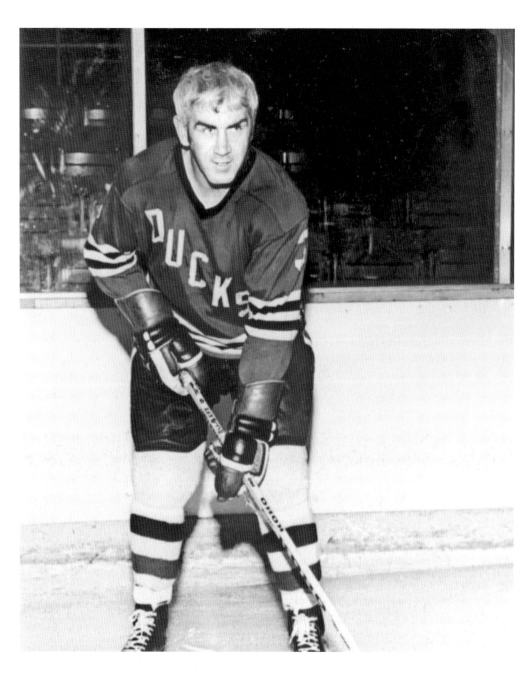

JOHN BROPHY (DEFENSE). Brophy is the all-time penalty minutes king (3,825) of the EHL and also played more games (1,141) than anyone else in league history. The defenseman skated four seasons with Charlotte (1956–1960) and was a member of the 1956–1957 championship team. Brophy also won an EHL playoff crown with Long Island (1964–1965). As a coach, he won three ECHL playoff championships with Hampton Roads (1990–1991, 1991–1992, and 1997–1998). The defenseman piloted Toronto (NHL) for three seasons (1986–1989) and compiled a 64-111-18 regular season record.

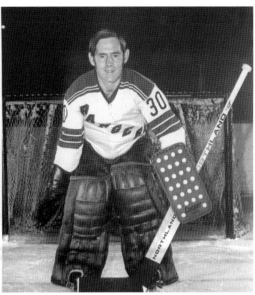

GILLES VILLEMURE (GOALIE). A veteran of 10 NHL seasons between 1963 and 1977, Villemure had a 2.81 GAA and a 100-64-29 record in 205 games. He shared the NHL's Vezina Trophy for outstanding goaltender in 1970–1971. Villemure won consecutive AHL MVP awards (1968–1969 and 1969–1970) and a Calder Cup (AHL) in 1969–1970. He was loaned to Charlotte by Long Island (EHL) in 1961–1962 and had a 7.00 GAA and a 0-1-0 record.

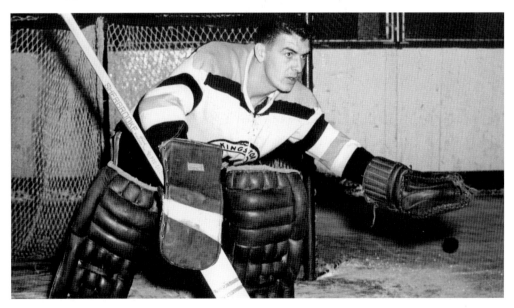

NORM JACQUES (GOALIE). Jacques had a 4.15 GAA in 20 games with the Checkers during the 1961–1962 season. Most of his career was spent in the IHL (1961–1968). The net minder also played in the QHL (1956–1957), AHL (1958–1959), and EPHL (1959–1961).

LEO OLIVIER (DEFENSE). Olivier had 26 points, 22 assists, and 112 PIM in 68 games with the Checkers in 1962–1963. He played the next six seasons in Nashville (1963–1969) and won two playoff championships with the Dixie Flyers in 1965–1966 and 1966–1967. The defenseman was named to the EHL all-star team in 1966–1967 and 1968–1969.

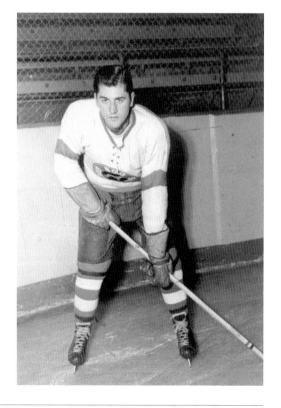

MARCEL CLEMENTS (LEFT WING). In 1960–1961, Clements had 31 points, 19 assists, and 65 PIM with Charlotte. The left winger also played in the EHL with Washington (1957–1959), Knoxville (1961–1962), and Nashville (1962–1963). He won an Atlantic City Boardwalk Trophy championship with Washington in 1957–1958. Clements spent one season in the IHL with Indianapolis in 1959–1960.

EASTERN HOCKEY LEAGUE CHAMPIONS

MIKE KARDASH (DEFENSE). He had 35 points, 30 assists, and 189 PIM in 67 games in his one season with the Checkers (1962–1963). Kardash played in seven EHL seasons (1958–1960 and 1962–1967) with Charlotte, Clinton, Greensboro, and Philadelphia. The defenseman was a member of Clinton's Atlantic City Boardwalk Trophy championship team in 1958–1959. He also spent time in the WHL (1960–1962) and IHL (1961–1962).

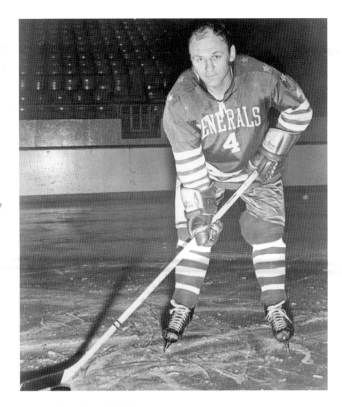

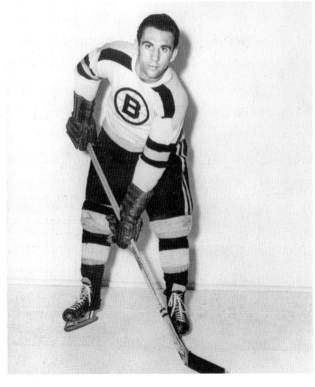

PETE HORECK (RIGHT WING). Horeck was a veteran of eight NHL seasons (1944–1952). He had 224 points, 106 goals, and 340 PIM in 426 NHL games. The right winger played one season with the Clippers (1959–1960) and collected two points, one goal, and 22 PIM in 15 games. Horeck also played in the EHL (known as the EAHL from 1933 to 1954) with Atlantic City (1941–1942). He also spent two seasons in the AHL (1942–1944).

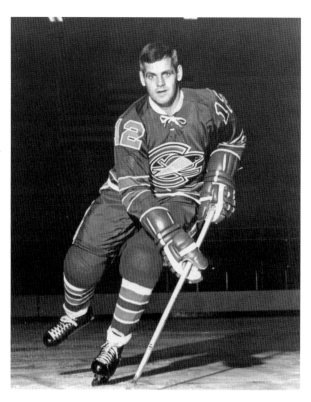

ALAIN "BOOM BOOM" CARON (RIGHT WING). Caron played 13 games for Charlotte in 1962–1963 and had 15 points and 10 goals. The right winger set the all-time record for goals in a season in the Eastern Professional Hockey League (EPHL) (61) in 1962–1963 and the CHL (77) in 1963–1964 and tied a professional hockey record (at the time) for goals in a season (78) while playing in the NAHL in 1975–1976. The sniper tallied 640 regular season goals in his professional career.

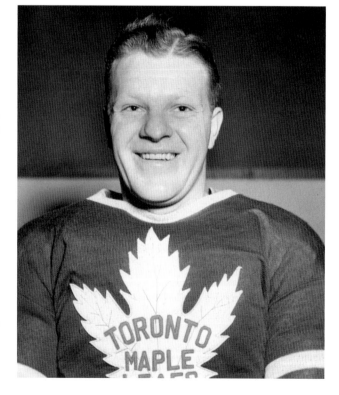

WALTER "TURK" BRODA (COACH). He was inducted into the Hockey Hall of Fame in 1967 and is the only Charlotte Checker to have that honor. In 1963–1964, Broda piloted Charlotte to a 30-41-1 (.424) record and a playoff berth. As a player, Broda twice won the Vezina Trophy (given to outstanding goalies) and had a 2.53 GAA and a 302-224-101 record during his 14 NHL seasons (between 1936 and 1952). The net minder won five Stanley Cups with Toronto (1942, 1947, 1948, 1949, and 1951).

FRANCIS ROGGEVEEN (DEFENSE). The defenseman had 23 points, 21 assists, and 16 PIM in 44 games with the Checkers (1963–1964). Roggeveen also played in the WHL (1954–1959 and 1960–1962), the EPHL (1959–1960 and 1961–1962), and the American Hockey League (AHL) (1961–1962).

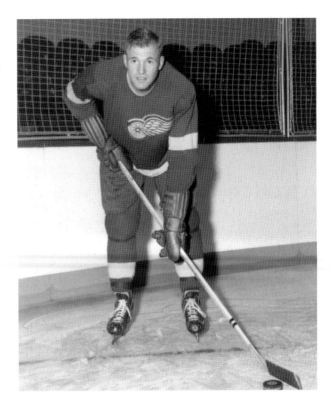

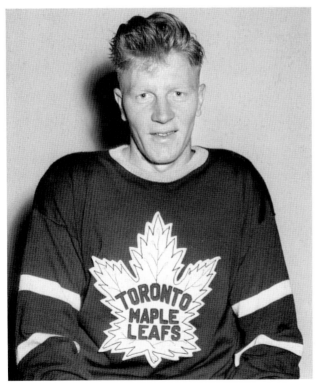

BILL "RED" JOHANSEN (CENTER). The center had 26 points, 16 goals, and 6 PIM in 27 games with Charlotte in 1963–1964. The following season he remained in the EHL with New York. Red won a Calder Cup with Providence (AHL) in 1955–1956 and a President's Cup with Vancouver (WHL) in 1957–1958. He had a stint in the NHL in 1949–1950 and also spent time in the Quebec Hockey League (QHL) from 1953 to 1955.

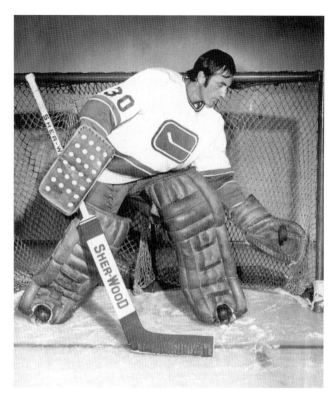

JACQUES CARON (GOALIE). He had a 5.20 GAA in five games with Charlotte (1961–1962). Caron played five seasons in the NHL (between 1967–1974) and had a 24-29-11 record and a 3.29 GAA in 72 games. In his two seasons in the WHA from 1975 to 1977, he compiled a 2.91 GAA and a 14-6-3 record in 26 matches. He was a member of a Calder Cup (AHL), a Patrick Cup (WHL), and a Lockhart Cup (NAHL) winning team.

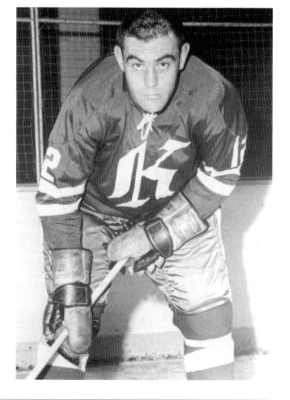

BOB DUNCAN (DEFENSE). Duncan had 22 points, 17 assists, and 53 PIM in 48 games with Charlotte in 1963–1964. He also played in the EHL with Knoxville (1961–1963) and Jacksonville (1964–1965). The defensive player spent time in the AHL (1956–1957), the QHL (1957–1959), the EPHL (1959–1960), and the IHL (1963–1964).

NORM "RED" ARMSTRONG
(DEFENSE). In his two seasons
with the Checkers (1960–1962),
he collected 22 points and 194
PIM in 66 games. Red was a
member of four Calder Cup
(AHL) teams in Rochester
(1964–1965, 1965–1966, and
1967–1968) and Springfield
(1970–1971). He played seven
games in the NHL with Toronto
during the 1962–1963 season
and registered two points and
one goal.

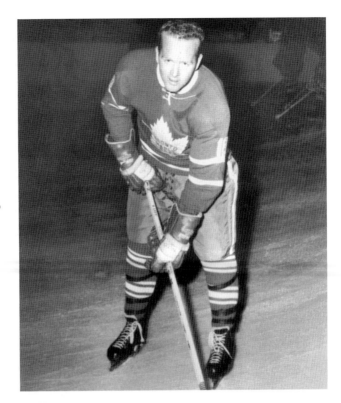

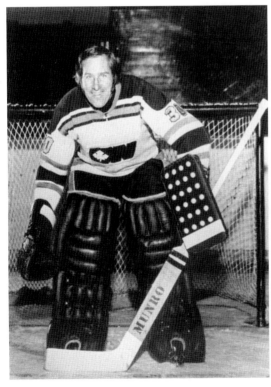

LES BINKLEY (GOALIE). He helped lead
the Clippers to the 1956–1957 Atlantic
City Boardwalk Trophy championship
(EHL) with a 50-13-1 record and a 3.79
GAA. Binkley played two seasons with
Charlotte (1956–1958) and had an
88-38-2 record and a 3.72 GAA in 128
games. The goaltender spent five years in
the NHL (1967–1972) and earned a 3.12
GAA and a 58-94-34 mark in 196 games.

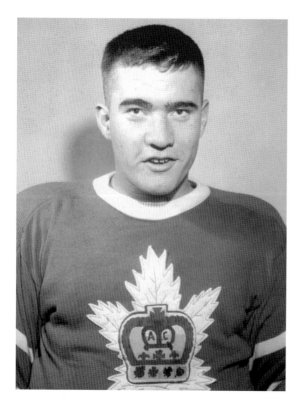

FRANK RIDLEY (DEFENSE). He had 58 points, 42 assists, and 64 PIM in 72 games for the Checkers in 1963–1964. The defenseman played the following season in the EHL with Knoxville.

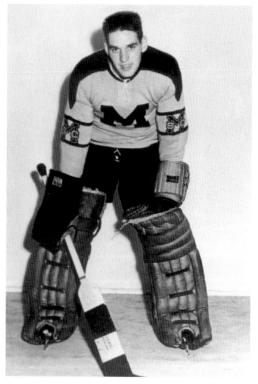

GERRY MCNAMARA (GOALIE). The net minder had a 3.76 GAA in 29 games with Charlotte in 1963–1964. He had two stints in the NHL (1960–1961 and 1969–1970) and compiled a 2.60 GAA and a 2-2-1 record in seven games. McNamara was also between the pipes in the AHL (1955–1963), the WHL (1956–1957), and the EPHL (1959–1961).

EASTERN HOCKEY LEAGUE CHAMPIONS

YVES SARRAZIN (RIGHT WING). He had 41 points, 20 goals, and 34 PIM in 40 games during his two seasons in Charlotte (1960–1962). The right winger also played in the QHL (1958–1959) and the EPHL (1959–1961).

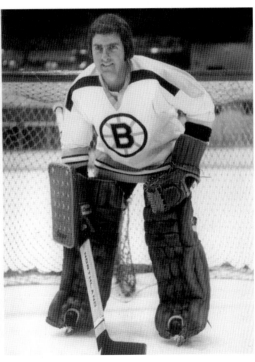

ROSS BROOKS (GOALIE). In 1963–1964, Brooks was signed as an emergency injury replacement goaltender by the EHL. He made stops in Charlotte, Johnstown, Nashville, and Philadelphia that season, and had a 4.25 GAA in 16 games. Brooks spent three seasons in the NHL (1972–1975) and compiled a 2.64 GAA and a 37-7-6 record in 54 games.

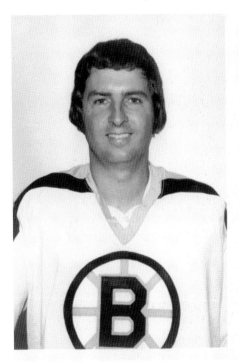

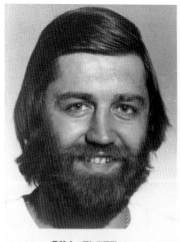

BILL FLETT

BILL "COWBOY" FLETT (RIGHT WING). Flett was a veteran of 13 NHL seasons (1967–1980), and garnered 417 points, 202 goals, and 501 PIM in 689 games. He won a Stanley Cup with Philadelphia in 1973–1974. In his only season with Charlotte (1963–1964), he had 47 points, 26 goals, and 48 PIM in 41 games.

GEORGES ROY (DEFENSE). Roy had 61 points, 51 assists, and 77 PIM in 68 games in 1961–1962 with Charlotte. The defenseman spent most of his career in the QHL (1952–1959) and also played in the AHL (1959–1960), the WHL (1960–1961), and the EPHL (1960–1961). Besides the Checkers, he skated in the EHL with New Haven (1964–1965), Johnstown (1967–1968), and Nashville (1968–1969).

3

HOCKEY NIGHTS IN DIXIE

The Checkers broke even (35-35-2) in the 1964–1965 season with a third place finish in the South Division. The locals bowed out in the quarterfinals that season against the Nashville Dixie Flyers three games to none. New player/coach Fred Creighton (who would pilot the team through the 1971–1972 season) was named a South Division second team all-star as a defenseman and as a coach.

Creighton, now strictly a bench coach, led his team to their first winning season (42-30-0) in three years with a second place finish in the South Division in 1965–1966. Creighton once again was named a second-team South Division all-star as coach, and George Hill's 105 points placed ninth in EHL scoring. Charlotte beat Greensboro in the quarterfinals three games to two, but was again swept by Nashville in four straight in the semifinals. The EHL instituted an all-star game that was held at Commack, Long Island, on January 11, 1966. Moe Savard was the only Checker representative in a game that pitted the defending EHL champion Long Island Ducks against an all-star team composed of players from the other EHL squads. The Ducks lost the game 4-1.

In 1966–1967, the Checkers had a second consecutive second-place finish (36-33-3) in their division. Ralph Winfield (defense) and Lynn Zimmerman (goalie) were named second-team South Division all-stars. The 1967 EHL all-star game in Nashville on February 21, 1967, was between the defending champion Dixie Flyers and the EHL North Division All-Stars. Thus, no Checkers were invited. Nashville won game 3-1. In the playoffs, Charlotte swept Greensboro in three straight games in the quarterfinals. The Checkers' postseason hopes were ended by Nashville for the third consecutive season, losing to the Dixie Flyers in the semifinals four games to one.

In 1967–1968, a South Division championship eluded Creighton's team for the third year in a row as the locals finished in second place (42-21-9) just five points behind the leaders. The Checkers finally disposed of their old postseason nemesis Nashville, beating their South Division rivals three games to one in the quarterfinals. Charlotte defeated Greensboro in the semifinals four games to two and advanced to their first finals appearance since the 1957–1958 season. Unfortunately, the Checkers met the Clinton Comets in the finals. Clinton was coming off the greatest regular season in minor-league hockey history (57-5-10, .861). The Comets swept Charlotte in four games, but every game was exciting. Rick Foley (defense), who set the all-time Checkers' single-season assist record with 78 in 1967–1968, made the South Division all-star team.

The locals had a 37-29-6 record and a third place finish in 1968–1969. In the postseason, Charlotte was swept in the quarterfinals by Nashville three games to none. Defenseman Rick Foley was named to the South Division all-stars for the second year in a row.

In 1969–1970, the Checkers secured their fifth consecutive regular season winning record (34-31-9) and landed in third place. In the quarterfinals, they beat the Salem Rebels four games to one but were stopped in the semifinals by Greensboro four games to two. Charlotte's Tom Trevelyan was named South Division Rookie of the Year.

RICK FOLEY (DEFENSE). Foley came to the Checkers in the postseason of 1966–1967. He remained with Charlotte over the next two seasons and had 175 points, 136 assists, and 408 PIM in 137 games. The defenseman played three seasons in the NHL (1970–1972 and 1973–1974), and collected 37 points and 180 PIM in 67 games. Foley was a member of Patrick Cup–winning Portland (WHL) in 1970–1971.

RON HUTCHINSON (CENTER). In 1964–1965 with the Checkers, the center produced 50 points, 20 goals, and 33 PIM in 59 games. Hutchinson played nine games in the NHL during the 1960–1961 season. He spent most of his career in the WHL (1957–1967), where he won two President's Cups with Vancouver in 1957–1958 and 1959–1960.

LARRY McKILLOP (LEFT WING). In 1966–1967 with Charlotte, he had 49 points, 22 goals, and 32 PIM in 72 games. The left winger went on to play seven seasons in the AHL with Quebec (1967–1970), Hershey (1970–1971), and Rochester (1972–1975) and one season in the CHL with Omaha (1971–1972).

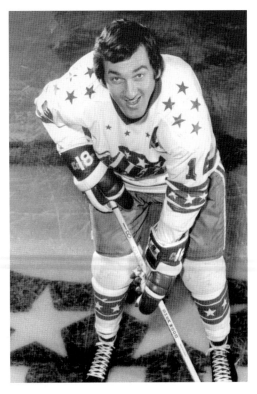

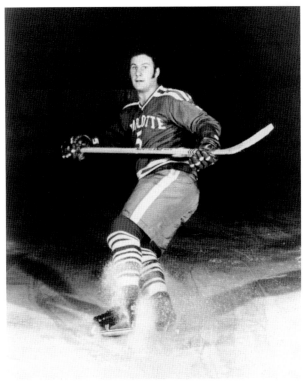

HAL WILLIS (DEFENSE). The defenseman played two seasons with Charlotte (1969–1971) and was a member of the 1970–1971 EHL championship team. Willis amassed 483 PIM, 132 points, and 97 assists in 139 games with the Checkers. He also skated in the EHL with Long Island (1967–1969) and played in the WHA from 1972 to 1974 with New York and Los Angeles.

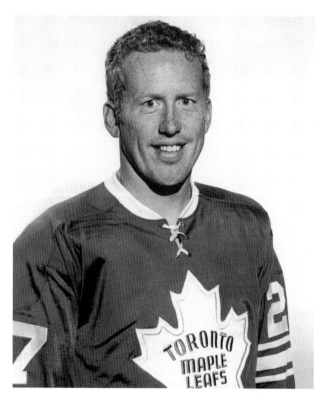

RANDY MURRAY (DEFENSE). In 1966–1967, Murray had 35 points, 10 goals, and 148 PIM in 65 games with the Checkers. He had a stint in the NHL in 1969–1970. The defenseman played most of his career in the CHL (1966–1971 and 1972–1973) and was a member of Adams Cup–winning Tulsa in 1967–1968.

ROGER OUIMET (CENTER). In his three seasons with Charlotte from 1967 to 1970, he accumulated 120 points, 54 goals, and 96 PIM in 121 games. Prior to his time in the EHL, he played in the IHL with Dayton (1964–1966) and Des Moines (1966–1968).

ANDRE HINSE (LEFT WING). In his two seasons with Charlotte (1965–1967), Hinse had 141 points, 74 goals, and 100 PIM in 141 games. He skated in four WHA seasons (1973–1977), and collected 253 points and 102 goals in 256 games. He won two Avco World Trophies (WHA) with Houston (1973–1974 and 1974–1975), an Adams Cup with Tulsa (CPHL) in 1967–1968, and a Patrick Cup with Phoenix (WHL) in 1972–1973. Hinse played four games for Toronto in the NHL (1967–1968).

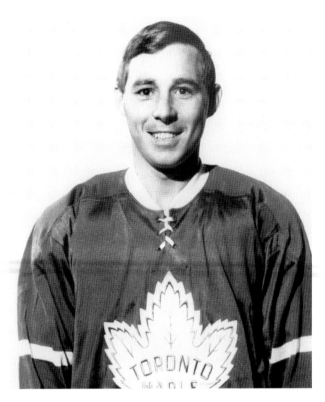

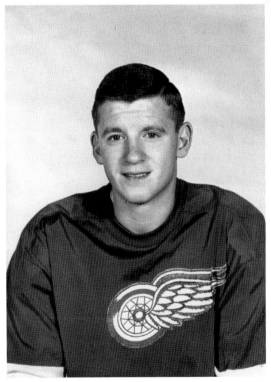

TOM TREVELYAN (CENTER). He had 77 points, 39 goals, and 33 PIM in 54 games with Charlotte in 1969–1970. Trevelyan made it to the major leagues with San Diego (WHA) in 1974–1975, and he had two points and four PIM in 20 games. The center spent most of his career in the WHL (1969–1970 and 1971–1974) and played two seasons in the AHL (1970–1972) and one in the NAHL (1974–1975).

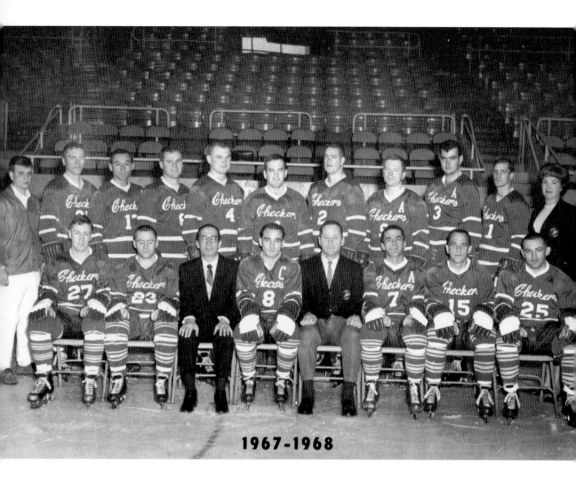

1967-1968

1967–1968 CHARLOTTE CHECKERS. Pictured here from left to right are (first row) Jack McCreary, Ken Hicks, Al Manch (team president), Art Hart, Fred Creighton (coach), Moe Savard, Chuck Stuart, and Ron Spratt; (second row) Mickey Willyard (trainer), Roger Ouimet, Ernie Dyda, Ted Baylis, Jim Lane, Bob Whidden, Bob Shupe, Claude Ouimet, Rick Foley, Barry Simpson, and Janie Van Buren (office manager).

HOCKEY NIGHTS IN DIXIE

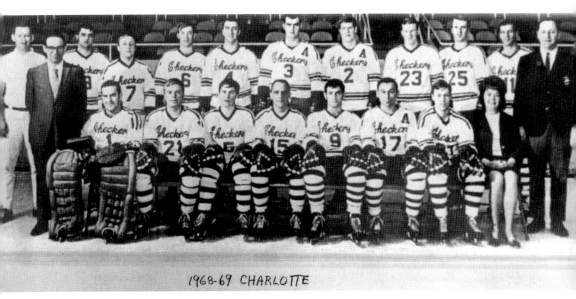

1968-69 CHARLOTTE

1968–1969 CHARLOTTE CHECKERS. From left to right are (seated) Bob Whidden, Roger Ouimet, Allie Sutherland, Chuck Stuart, Tim McCormack, Ernie Dyda, Jack McCreary, and Janie Van Buren (office manager); (standing) Jerry Maloney (trainer), Al Manch (team president), Neil Clark, Jack Wells, Barry Burnett, Frank Golembrosky, Rick Foley, Bob Shupe, Pete Shearer, Bob Graham, Barry Simpson, and Fred Creighton (coach).

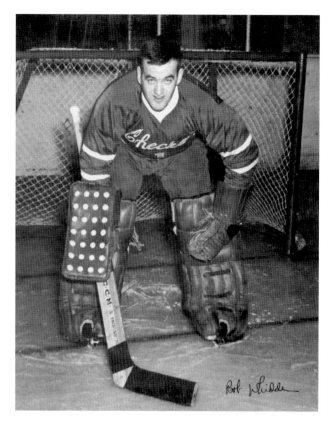

Bob Whidden (Goalie). Whidden posted a 3.54 GAA in 114 games during his two seasons with Charlotte between 1967 and 1969. He played four years in the WHA (1972–1976) and had a 3.43 GAA and a 34-51-9 record in 98 games. The net minder also spent time in the AHL (1969–1972) and the NAHL (1973–1974 and 1976–1977).

Neil Clark (Center). Clark had 131 points, 61 goals, and 174 PIM in 148 games during his three seasons with the Checkers (1967–1970). The center played in the EHL with the New Haven Blades (1970–1973) (The team played as the New England Blades in 1972–1973). He also spent time in the AHL (1965–1966), CPHL (1966–1968), and the WHL (1966–1968).

BUTCH PAUL (CENTER). Paul had 41 points, 27 goals, and 50 PIM in 30 games with the Checkers in 1964–1965. The center had a stint in the NHL in 1964–1965. He also spent time in the AHL and the CPHL.

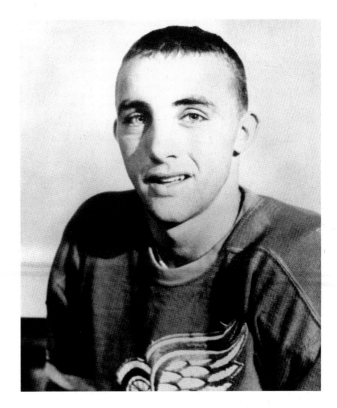

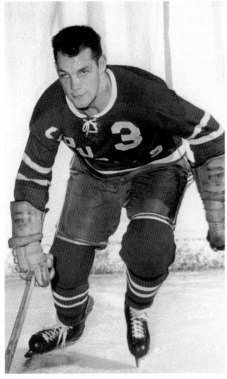

BILL DOBBYN (DEFENSE). Dobbyn briefly played for Charlotte during the 1964–1965 season. He had two points (both goals) in three games with the Checkers that year. The defenseman also played in the WHL (1954–1958) and the IHL (1964–1965). He won a President's Cup with Vancouver (WHL) in 1957–1958.

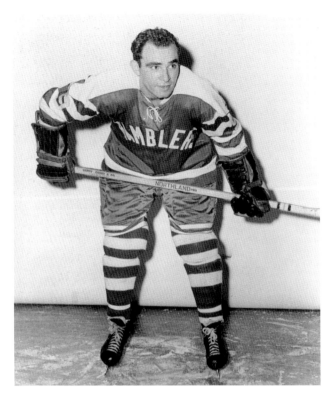

ART HART (RIGHT WING). Hart played four seasons with Charlotte (1965–1968 and 1969–1970) and had 224 points, 109 goals, and 276 PIM in 232 games. He had 1,094 PIM in his professional hockey career. The right winger also skated in the EHL with Philadelphia (1960–1964). Hart spent time in the WHL (1956–1959) and the IHL (1959–1960).

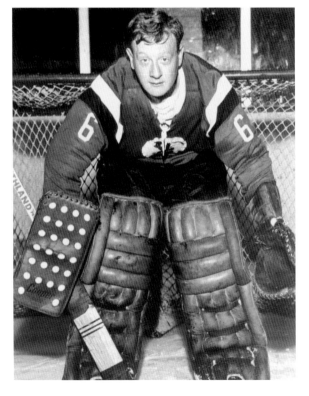

RICK CHARRON (GOALIE). Charron had a 3.42 GAA and three shutouts in 50 games with Charlotte during the 1965–1966 season. He played three other seasons in the EHL with Long Island (1962–1964) and New York (1964–1965) and was named an EHL all-star in 1964–1965. The net minder was a member of Calder Cup–winning Springfield (AHL) in 1974–1975.

ARCHIE MACDONALD (RIGHT WING).
He split the 1969–1970 season between
Charlotte and Johnstown and had 58
points, 33 assists, and 32 PIM in 70 games
between the two teams. MacDonald also
played in the EHL in 1972–1973 with
Jersey and Johnstown and in the SHL with
Winston-Salem in 1974–1975.

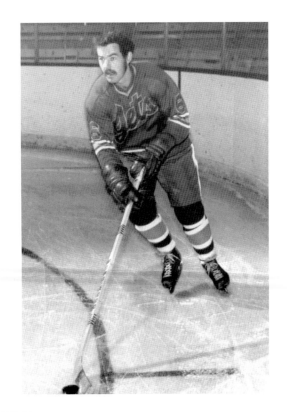

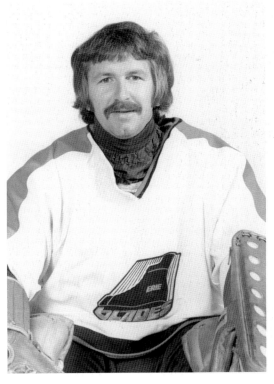

LYNN ZIMMERMAN (GOALIE).
Zimmerman had a 3.20 GAA in 72
games during the 1966–1967 season with
Charlotte. Zimmerman played in the
WHA (1975–1976 and 1977–1978) and
had a 4.15 GAA and a 12-15-0 record in
28 games. The net minder won a Calder
Cup with Rochester (AHL) in 1967–
1968 and a Patrick Cup with Vancouver
(WHL) in 1969–1970.

SAM GREGORY (CENTER). He had 78 points, 53 assists, and 193 PIM in 72 games with the Checkers during the 1964–1965 season. Gregory was a veteran of nine EHL seasons (1959–1968) with seven different teams—Charlotte, Greensboro, Johnstown, Long Island, New Haven, New York, and Salem. The center was a member of EHL (Johnstown, 1959–1960) and IHL (Indianapolis, 1957–1958) championship teams.

DON WALLIS (GOALIE). Wallis had a stint with Charlotte during the 1968–1969 season and was between the pipes in only one game, posting a 5.00 GAA. The net minder played in the WHL (1966–1967 and 1970–1972), the CHL (1971–1973), the AHL (1972–1973), and the NAHL (1973–1974).

4

BACK-TO-BACK

WALKER CUP CROWNS

The Charlotte Checkers captured back-to-back playoff championships in 1970–1971 and 1971–1972. The locals were only the sixth team in EHL history to accomplish that feat. Boston (1945–1946 and 1946–1947), Johnstown (1951–1952 and 1952–1953), Johnstown (1959–1960 to 1961–1962), Nashville (1965–1966 and 1966–1967), and Clinton (1967–1968 to 1969–1970) were the other teams to capture two or more titles in a row. Charlotte was also only the second Southern city in professional hockey history to win consecutive postseason championships. Since the 1963–1964 season, the playoff champion of the EHL was awarded the Walker Cup. The Atlantic City Boardwalk Trophy, given to the EHL playoff champion from 1951–1952 to 1962–1963, was awarded to the EHL's South Division winner in 1963–1964 and 1964–1965 and to the EHL's North Division winner from then on.

In 1970–1971, the Checkers achieved the second highest win (55) and point (117) totals in league history. The locals attained their third regular-season title and their first since the 1957–1958 season. It was also Charlotte's first South Division title (the EHL had a divisional format since 1959–1960). The Checkers skated through the playoffs with a near perfect 12-1 record, sweeping Nashville and Greensboro during the first two rounds in four straight games each and then defeating the New Haven Blades four games to one for the championship. Fred Creighton, who led his team to a 55-12-7 regular season record, was named *Hockey News* Minor League Coach of the Year. Creighton was also named to the South Division all-star team along with John Voss (goalie). Voss completed the regular season with a 1.87 GAA and became the first goaltender to dip below the 2.00 GAA mark since the mid-1930s. The net minder was awarded the EHL's George L. Davis Jr. Trophy for leading goaltender. Mike Rouleau, fifth in points with 108, became the first Checker player in five seasons to crack the EHL's top 10 in scoring.

Charlotte earned its fourth regular-season championship (102 points) and its second South Division title in 1971–1972 with a 47-18-8 record. Frank Golembrosky (right wing), Mike Rouleau (center), and Allie Sutherland (left wing) were named to the South Division all-star team. Golembrosky (fourth with 106 points) and Rouleau (fifth with 105 points) placed in the league's top 10 in scoring. Gaye Cooley won the Davis Trophy as the EHL's leading goaltender with a 2.37 GAA. Don Brennan was named South Division Rookie of the Year. The Checkers had a 12-3 postseason record on the road to their second consecutive Walker Cup and third EHL playoff championship overall. The locals beat the Suncoast Suns (based in St. Petersburg) in the quarterfinals four games to two, Greensboro in the semifinals four games to one, and then swept the Syracuse Blazers in four straight games in the finals.

Checker player Jack Wells was promoted to player/coach in 1972–1973 as Creighton moved up to the CHL with Omaha. Only six players returned to the team from the previous year's

squad, and the Checkers fell to last place in their division with a 26-40-10 record and missed the postseason for the first time since 1961–1962.

The 1972–1973 season would be the last campaign for the EHL, which dated back to 1933–1934. On May 1, 1973, it was announced that the EHL was dissolving into two new leagues—the Southern Hockey League (SHL) and the North American Hockey League (NAHL). Only one EHL franchise voted for retention of the existing league. The Southern teams heavily favored breaking loose from the EHL because of less travel. Former EHL president Thomas Lockhart, who served that office from 1937 to 1972, attended the final meeting at the New York's Barbizon Hotel and was upbeat, stating that the move should not be viewed as a wake but instead as a strengthening of all franchises involved.

During its EHL era, Charlotte won three playoff championships, four overall regular-season titles, and had an overall regular-season record of 613-500-72 (.548). The club made the playoffs in 13 of its 17 seasons, earned a 16-10 (.615) playoff series record, and had a 68-54 (.557) record in postseason games. Charlotte was the most successful Southern team in the history of the EHL.

FRED CREIGHTON (COACH/CENTER). He led the Checkers to two Walker Cup playoff championships during his eight seasons as head coach of the team (1964–1965 to 1971–1972). Creighton compiled a 328-209-44 (.602) regular season record with Charlotte. The center skated in four seasons with the Checkers (1961–1963 and 1964–1966) and produced 90 points, 76 assists, and 389 PIM in 204 games. He also played in the EHL with New Haven as a player/coach in 1963–1964 and spent time in the WHL (1955–1961) and IHL (1963–1964). Creighton coached in the NHL for six seasons with Atlanta (1974–1979) and Boston (1979–1980) and achieved a 196-156-69 record (.548).

JOHN GOULD (RIGHT WING). Gould skated with the Checkers for two seasons (1969–1971) and had 173 points, 100 assists, and 68 PIM in 141 games. He was a member of the 1970–1971 Charlotte championship team. The right winger went on to a nine-year NHL career (1971–1980). He complied 269 points, 131 goals, and 113 PIM in 504 NHL games. Gould won a Calder Cup with Cincinnati (AHL) in 1972–1973.

JOHN VAN HORLICK (DEFENSE). In his two seasons with the Checkers (1969–1971), he accumulated 389 PIM, 79 points, and 65 assists in 134 games. Van Horlick won a Walker Cup with Charlotte (1970–1971) and an Adams Cup with Salt Lake City (CHL) in 1974–1975. The defenseman had a stint in the WHA in 1975–1976. He also skated in the WHL (1971–1974), the AHL (1972–1974), and the NAHL (1975–1976).

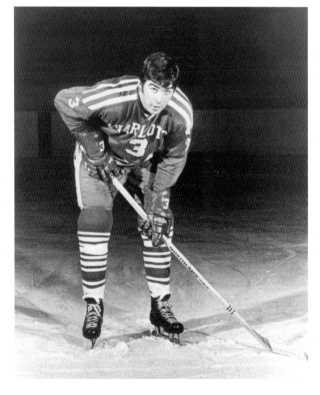

BOB RICHER (LEFT WING). Richer was a member of the Checkers' 1971–1972 Walker Cup championship team. He had 75 points, 44 goals, and 62 PIM in 71 games that season. The left winger played three seasons in the AHL (1971–1974) and was a member of Calder Cup–winning Cincinnati in 1972–1973. Richer had a stint in the NHL in 1972–1973.

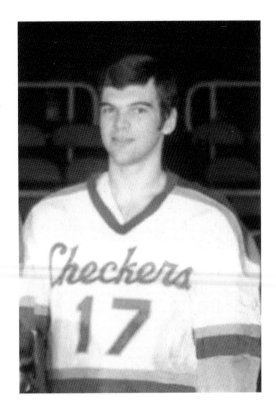

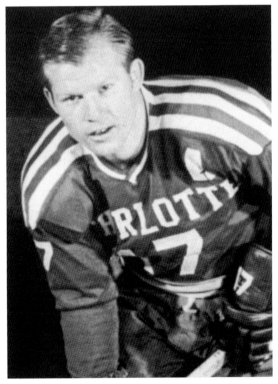

GREGG PILLING (RIGHT WING). He had 63 points, 25 goals, and 142 PIM for Charlotte's 1970–1971 Walker Cup–winning team. The right winger also played in the EHL for Suncoast in the 1971–1972 season and Roanoke Valley in the 1972–1973 season. Pilling went on to coach in the minors and piloted Roanoke Valley (SHL) to a Crockett Cup championship (1973–1974) and Philadelphia (NAHL) to a Lockhart Cup championship (1975–1976).

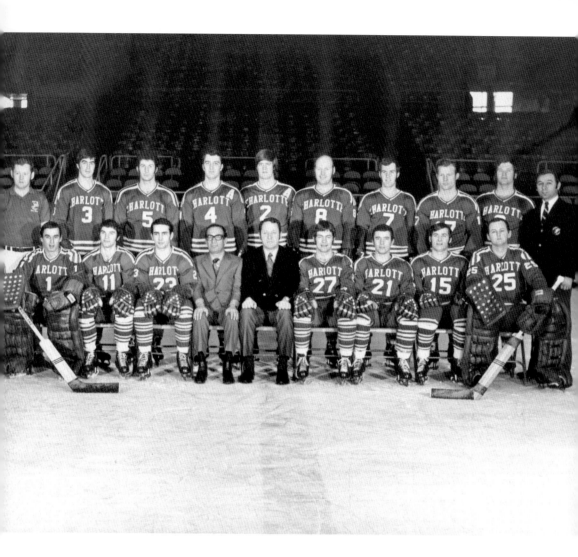

1970–1971 EHL Champions. Pictured here from left to right are (first row) John Voss, Wayne Schaab, Bob Mowat, Al Manch (team president), Fred Creighton (coach and general manager), Michel Rouleau, John Morrison, Al Sutherland, and Gord McRae; (second row) Jerry Maloney (trainer), John Van Horlick, Hal Willis, Frank Golembrosky, Bob Shupe, John Rodger, Mike Keeler, Gregg Pilling, John Gould, and Ernie Dyda.

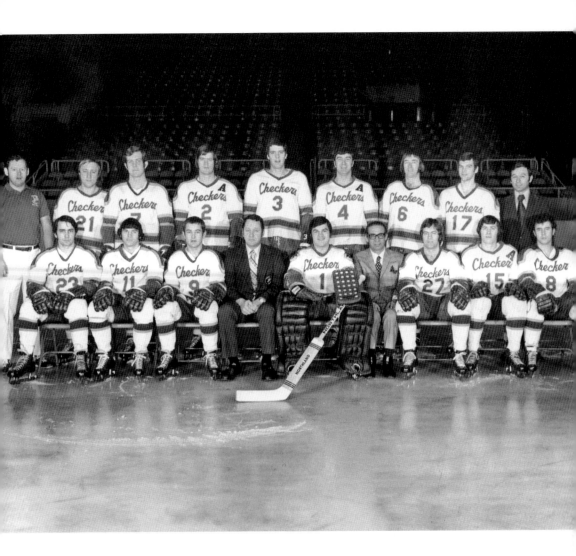

1971–1972 EHL Champions. Shown here are, from left to right, (first row) Bob Mowat, Wayne Schaab, unidentified, Fred Creighton (coach and general manager), Gaye Cooley, Al Manch (team president), Michel Rouleau, Al Sutherland, and John Morrison; (second row) Jerry Maloney (trainer), Jack Wells, Rick Loe, Bob Shupe, Yvon Bilodeau, Frank Golembrosky, Barry Burnett, Bob Richer, and Ernie Dyda.

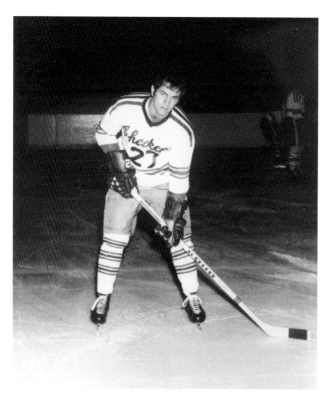

MICHEL ROULEAU (LEFT WING). He had 238 points, 148 assists, and 493 PIM in 170 games during his three years with the Checkers (1970–1972 and 1975–1976). Rouleau was a member of three Charlotte championship teams. The left winger spent three years in the WHA from 1972 to 1975 and collected 48 points, 35 assists, and 289 PIM in 115 games. He also played in the EHL with New Haven (1967–1970).

BOB MOWAT (RIGHT WING). During both of his seasons with Charlotte (1970–1972) the Checkers captured the Walker Cup. He had 140 points, 65 goals, and 176 PIM in 142 games during those championship seasons. The right winger won two Patrick Cups with Phoenix (WHL) in 1972–1973 and 1973–1974. He made it to the major leagues with Phoenix (WHA) and had 19 points, 10 assists, and 34 PIM in 53 games.

ERNIE DYDA (FORWARD). Dyda was a member of the Checkers' back-to-back Walker Cup championship teams in the 1970–1971 and 1971–1972 seasons. Dyda played seven seasons with Charlotte between 1965 and 1972. His biggest offensive output was in 1966–1967, when he had 66 points and 22 goals in 72 games. The forward also played in the EHL with Johnstown (1963–1964) and Jacksonville (1964–1966).

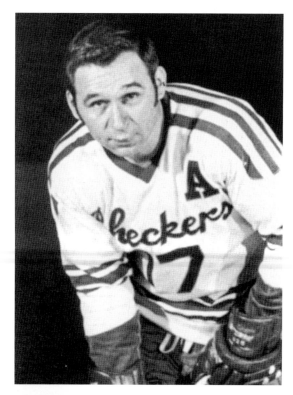

RICK LOE (LEFT WING). Loe was a member of Charlotte's Walker Cup championship team in 1971–1972. In his three seasons with the Checkers from 1971 to 1974, he had 129 points, 68 goals, and 208 PIM in 155 games. The left winger also skated with Johnstown in the EHL (1969–1971) and NAHL (1973–1974 and 1976–1977) and played in the SHL with Greensboro (1974–1975) and Winston-Salem (1975–1977).

YVON BILODEAU (DEFENSE). Bilodeau skated for the 1971–1972 Walker Cup playoff-champion Checkers. The defenseman had 29 points, 24 assists, and 140 PIM in 73 games with Charlotte that season. He had a stint in the WHA with Calgary in 1975–1976. Bilodeau also played in the AHL (1971–1973), CHL (1972–1973 and 1975–1976), IHL (1973–1975), and WHL (1973–1974).

CAL BOOTH (LEFT WING). Booth had 48 points, 23 goals, and 58 PIM in 58 games with the 1970–1971 Walker Cup champion Checkers. He was also with Charlotte the following year when they repeated as EHL playoff champions, but he split the season between Charlotte, New Jersey, and Long Island.

JOHN VOSS (GOALIE). Voss posted a 2.98 GAA in 122 games during his three seasons with Charlotte (1969–1971 and 1972–1973). He won the George L. Davis Jr. Trophy as leading goaltender in the EHL in 1970–1971 and his 1.87 GAA was the lowest in the league since the mid-1930s. The net minder helped the Checkers win the Walker Cup championship and was selected to the EHL South Division all-stars in 1970–1971.

JOHN RODGER (FORWARD). Rodger played three seasons with Charlotte (1969–1971 and 1972–1973) and was a member of the club's 1970–1971 Walker Cup championship team. The forward had 152 points, 66 goals, and 112 PIM in 134 games with the Checkers. He spent time in the EPHL (1961–1963), the AHL (1963–1965 and 1966–1969), and the WHL (1968–1971).

HOCKEY IN CHARLOTTE

GARY "BONES" BROMLEY (GOALIE). Bromley was between the pipes with Charlotte during the club's 1971–1972 Walker Cup championship season. He had a 2.70 GAA and four shutouts in 27 games that banner year. The net minder played six seasons in the NHL (1973–1976 and 1978–1981) and had a 3.43 GAA and a 54-44-28 record in 136 games. He won a Calder Cup with Cincinnati (AHL) in 1972–1973 and an Adams Cup with Dallas (CHL) in 1978–1979.

DAVE WHITE (LEFT WING). In 1972–1973, White had 19 points, 12 assists, and 28 PIM in 32 games with the Checkers. The left winger played most of his career in the IHL (1973–1977) and also played in the NAHL (1976–1977).

JACK TAGGART (DEFENSE). The defenseman had 11 points, nine assists, and 30 PIM in 24 games with the Checkers in 1972–1973. Taggart spent two seasons in the AHL (1971–1973) and was a member of Calder Cup–winning Cincinnati (1972–1973). He played one season in the CHL (1970–1971).

MICHEL BELHUMEUR (GOALIE). He played for Charlotte in 1969–1970 and had a 3.00 GAA and one shutout in 14 games. Belhumeur played three seasons in the NHL (1972–1973 and 1974–1976) and had a 4.61 GAA and a 9-36-7 record in 65 games.

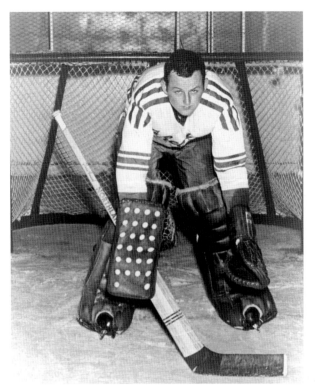

GORD McRAE (GOALIE). He played five seasons in the NHL (1972–1973 and 1974–1978), and had a 3.49 GAA and a 30-22-10 record in 71 games. McRae played with Charlotte during their 1970–1971 Walker Cup championship season and also played in the EHL with New Jersey and Jacksonville that year. He had a 2.88 GAA in 24 EHL games in 1970–1971. The net minder also spent time in the AHL and CHL.

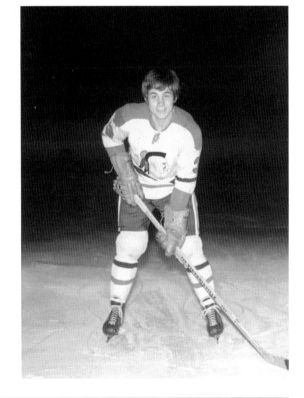

ED SIDEBOTTOM (DEFENSE). Sidebottom spent the 1971–1972 season in the EHL with Charlotte and New Haven and in the IHL with Muskegon and Des Moines. He had nine points, seven assists, and 27 PIM in 16 EHL games. The defenseman split the following season between the CHL and the IHL and finished his professional career in the IHL in 1973–1974.

RICH KRAMP (CENTER). Kramp played seven games with Charlotte in 1972–1973 and had two points and six PIM. The center spent most of his career in the IHL (1974–1975 and 1977–1981). He also played in the revived EHL in 1980–1981.

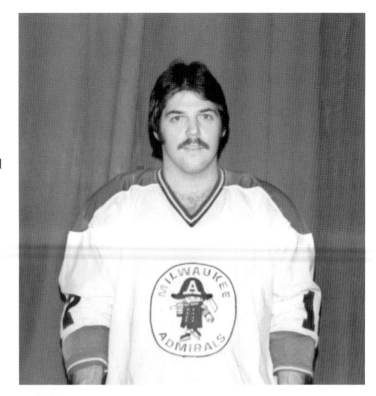

WAYNE SCHAAB (CENTER). Schaab had 168 points, 74 goals, and 60 PIM in 146 games during the Checkers' back-to-back Walker Cup playoff championship teams. The center went on to play in the CHL (1972–1975) and AHL (1975–1976 and 1977–1983). He won an Adams Cup with Omaha (CHL) in 1972–1973 and two Calder Cups with Maine (AHL) in 1977–1978 and 1978–1979. Schaab was named the CHL's most valuable player in 1974–1975.

JACK WELLS (LEFT WING/COACH). Wells was player/coach for Charlotte during the 1972–1973 season. He piloted the team to a 26-40-10 (.408) record. In his seven seasons with the Checkers (1968–1970, 1971–1973, and 1974–1977), he had 330 points, 213 assists, and 736 PIM in 389 games. Wells was a member of three Checker championship teams—one EHL (1971–1972) and two SHL (1974–1975 and 1975–1976).

Charlotte Checkers

EASTERN HOCKEY LEAGUE CHAMPIONS

PRICE 35¢

1971–1972 Checkers Program. In 1971–1972, Charlotte won the EHL's Walker Cup playoff championship, the regular-season title, and the South Division crown for the second consecutive season. Frank Golembrosky, who placed fourth in the EHL in scoring, led the team with 106 points, while Bob Richer led the team in goals with 44. Gaye Cooley was the EHL's leading goaltender that season with a 2.37 GAA.

BOB SHUPE (DEFENSE). Shupe is the all-time PIM leader (1,076) in Charlotte history. In his seven seasons with the Checkers from 1967 to 1974 he also had 110 points and 93 assists in 369 games. Shupe was a member of both Checkers Walker Cup playoff championship teams. He also skated in the EHL with Johnstown (1968–1969) and Greensboro (1972–1973) and in the AHL with Rochester (1968–1969).

BACK-TO-BACK WALKER CUP CROWNS

5

THE SOUTHERN
HOCKEY LEAGUE

A new landmark in minor-league hockey had arrived. For the first time in professional hockey history, there was an interstate league that was based entirely in the Southern region of the United States—the Southern Hockey League (SHL). Former EHL members Charlotte, Greensboro, Roanoke Valley, and Suncoast were joined by newcomers Macon (the Whoopees), and Winston-Salem (the Polar Twins) in the inaugural season of the SHL in 1973–1974.

SHL officials decided to name the playoff championship trophy the James Crockett Cup in honor of James Crockett Sr., the late, heavy-set promoter who was a long-time backer of hockey in Charlotte. Crockett died in 1973.

Longtime EHL veteran and successful coach Pat Kelly was hired as general manager and coach of the Checkers in the first season of the SHL. Charlotte started things off right in the new league with a 44-27-1 record and a second-place finish. In the semifinals, the locals beat Greensboro four games to two. In a seven-game thriller for the league championship against Roanoke Valley, the Checkers lost by a one-goal margin in the deciding game and came up short of capturing the SHL's first Crockett Cup. Garry Swain won the league's scoring title (98 points) and led the league in assists (64), while Danny Sullivan (2.66 GAA) and Gaye Cooley (3.09 GAA) finished first and second in league goaltending. Sullivan, whose season GAA would become the all-time SHL single-season record, made the SHL first-team all-stars, and Cooley (goalie), Perry Miller (defense), and Swain (center) were named to the SHL's second-team all-stars.

In 1974–1975, Charlotte won the SHL's regular-season title with a 50-21-1 record. In the playoffs, the Checkers swept Roanoke Valley in the semifinals in four games and then defeated the Hampton Gulls four games to two in the finals to capture the Crockett Cup. The locals had their second SHL-leading scorer in Steve Hull (114 points) and the league-leading goal scorer in Andre Deschamps (59); both marks would stand as all-time SHL single-season records. The locals also boasted the SHL's leading goaltender again with Cooley's 3.26 GAA. Cooley, Deschamps (left wing), and Hull (right wing) were named first-team SHL all-stars, and Barry Burnett (defense) was given a second-team slot. The Checkers also had their hand in all three SHL awards—Deschamps was co-MVP, Mike Hobin was named rookie of the year, and Pat Kelly shared coach of the year honors with Hampton's John Brophy.

A second consecutive SHL regular season title (42-20-10) and Crockett Cup playoff championship were won in 1975–1976. Charlotte beat Roanoke Valley in the semifinals four games to two and then repeated against Hampton in the finals in five games.

Cooley (goalie), Mike Keeler (defense), and Neil Korzack (left wing) made the SHL first-team all-stars, and Yvon Dupuis (left wing) earned a second-team selection. Four Checkers placed in

the SHL top 10 in scoring—Dupuis (second with 91 points), Bob Smulders (tied for fifth with 78 points), Korzack (sixth with 77 points), and Wayne Chrysler (10th with 66 points).

The SHL started the 1976–1977 season with seven teams, the most in its four-year history. Coach Kelly moved up to Birmingham of the WHA early in the season and was replaced by veteran Checker player Barry Burnett. Fortunes turned for the SHL, however, when both the Richmond Wildcats and Greensboro folded on January 3. Less than a week later, Winston-Salem disbanded when the ownership refused to participate in a league with less than six teams, and the Tidewater Sharks soon followed suit. The three remaining teams—Charlotte, Hampton, and the Baltimore Clippers—continued to play each other for three weeks and were hoping to join the North American Hockey League (NAHL) for the remainder of the season. The NAHL rejected this proposal on January 21. The final SHL regular-season game was on January 30 at the Charlotte Coliseum, where the Checkers beat Baltimore 9-2 in front of 2,200 fans. The locals finished with a 22-25-3 record in third place. The SHL ceased operations after that, and so did Charlotte.

The Checkers were the greatest team in the four-year history of the SHL, winning the most playoff and regular-season championships. Charlotte also had the best regular-season (158-93-15, .622), best playoff (23-11, .676), and best postseason series record (5-1, .833) of any SHL team.

The original Charlotte franchise took the ice for 21 seasons (1956–1977) and is the most successful professional hockey franchise that was ever based in the South—winning an unmatched five playoff championships and six regular-season titles. The club boasted a .561 regular season winning percentage (771-593-87). The franchise made the post season in 16 of a possible 20 campaigns. The Checkers had a 91-65 playoff record (.583) and won 21 of its 32 playoff series (.656).

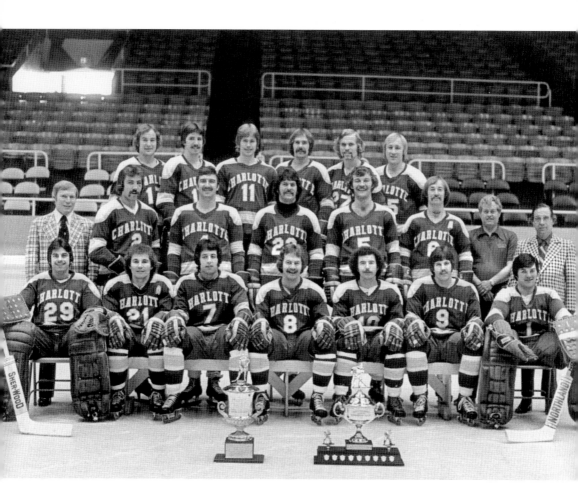

1975–1976 SHL CHAMPIONS. Pictured here from left to right are (first row) Bob Sauve, Wayne Chrysler, Yvon Dupuis, Michel Rouleau, John Morrison, Terry Martin, and Gaye Cooley; (second row) Pat Kelly (coach and general manager), Grant Rowe, Frank Golembrosky, Gary Wood, Bob Smulders, Barry Burnett, Bob Lambert (trainer), and Al Manch (team president); (third row) Don Brennan, Guy Burrowes, Neil Korzack, Mike Keeler, Jack Surbey, and Jack Wells.

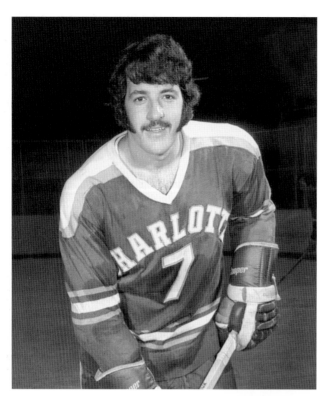

YVON DUPUIS (FORWARD). Dupuis is the all-time leading goal scorer (128) in SHL history and ranks fourth all time in the SHL in points (222). The forward notched all of his SHL goals and points during his three seasons with Charlotte (1973–1976), along with 94 assists and 75 PIM. He was a member of the Checkers' back-to-back Crockett Cup teams. He was named to the SHL second-team all-stars in 1975–1976.

WAYNE CHRYSLER (FORWARD). He is second all time in points (224), third all time in assists (145), and tied for eighth all time in goals (79) in SHL history. Chrysler had 224 points, 145 assists, and 177 PIM in 204 games with Charlotte (1973–1976). The forward was a member of both Checker Crockett Cup teams in 1974–1975 and 1975–1976.

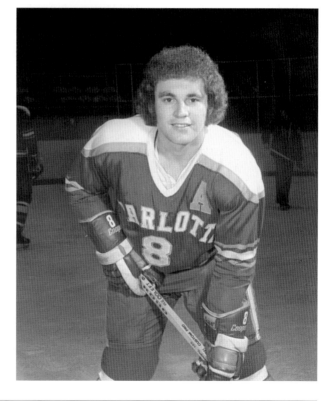

JOHN MORRISON (LEFT WING). Morrison played six years with Charlotte (1970–1976) and was a member of four playoff championship teams—two EHL (1970–1971 and 1971–1972) and two SHL (1974–1975 and 1975–1976). He had 295 points, 118 goals, and 357 PIM in 344 games with the Checkers.

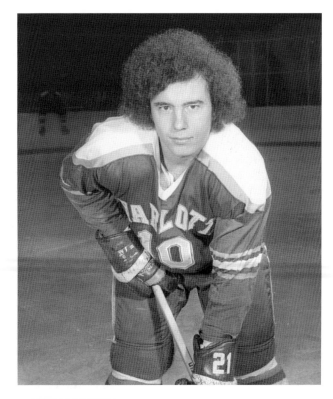

GARRY SWAIN (CENTER). The center produced over a point a game for the 1973–1974 Checkers—98 points in 68 games. He also had 34 goals and 84 PIM that season. Swain played three seasons in the WHA (1974–1977) and earned 55 points and 70 PIM in 171 games. Swain had a stint in the NHL with Pittsburg in 1968–1969 and had two points in nine games.

BARRY BURNETT (DEFENSE). The defenseman played nine years with Charlotte from 1968 to 1977 and was a member of four Checker championship teams—two in the EHL (1970–1971 and 1971–1972) and two in the SHL (1974–1975 and 1975–1976). He spent part of the EHL's 1970–1971 season with Jacksonville and played in the IHL for two seasons between 1967 and 1969. He became coach of the Checkers in the middle of the 1976–1977 season and compiled a 12-18-3 (.409) record.

MIKE KEELER (DEFENSE). In his four seasons with Charlotte (1970–1971 and 1974–1977), the defenseman had 171 points, 118 assists, and 276 PIM in 246 games. Keeler was a member of three Checker championship teams: 1970–1971, 1974–1975, and 1975–1976. He played in five other minor leagues—the AHL, EHL, NAHL, WHL, North Eastern Hockey League (NEHL), and Pacific Hockey League (PHL). The defenseman had a stint in the WHA (1973–1974).

WILLIE TROGNITZ (FORWARD).
Trognitz had 10 points, five
goals, and 140 PIM in 48 games
with Charlotte in 1973–1974. He
spent one season in the WHA
with Cincinnati (1977–1978)
and collected three points, two
goals, and 94 PIM in 29 games.
The forward spent most of his
career in the IHL (1974–1978),
where he won a Turner Cup with
Toledo in 1974–1975. He also
skated in the PHL (1978–1979)
and the CHL (1979–1980).

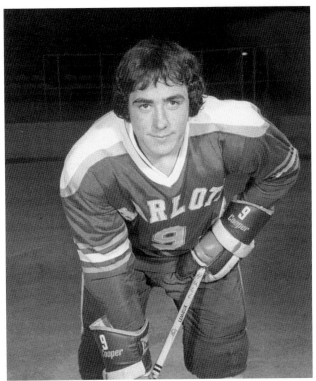

STEVE HULL (CENTER). He
played two seasons with the
Checkers between 1973 and 1975
and had 165 points, 106 assists,
and 89 PIM in 123 games. Hull
was a member of Charlotte's
Crockett Cup championship
team of 1974–1975. He played
two years in the WHA (1975–
1977) and produced 28 points, 17
assists, and six PIM in 60 games.
Hull also played in the SHL
with Tidewater (1976–1977).

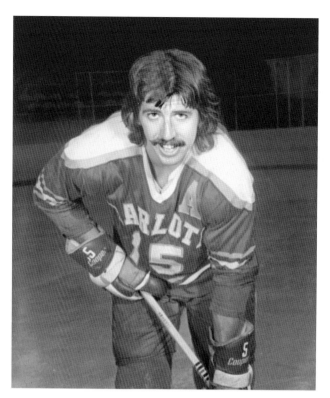

GUY BURROWES (CENTER). Burrowes played in all four SHL seasons with Charlotte (1973–1977) and won two Crockett Cups with the Checkers. He is first all time in games (262), second all time in assists (153), and third all time in points (223) in SHL history. The center also had 106 PIM with the locals. Prior to coming to Charlotte, he played one season in the AHL (1972–1973).

DON BRENNAN (DEFENSE). In all three of his seasons with Charlotte (1971–1972 and 1974–1976), the club won the playoff championship. Brennan had 90 points, 71 assists, and 161 PIM in 158 games with the Checkers. He is tied for seventh all-time in assists (129) in SHL history. The defenseman skated in four AHL seasons from 1971 to 1975 and won a Calder Cup with Cincinnati in 1972–1973.

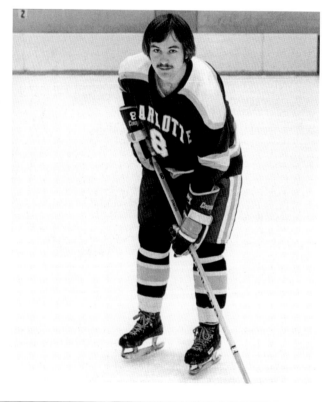

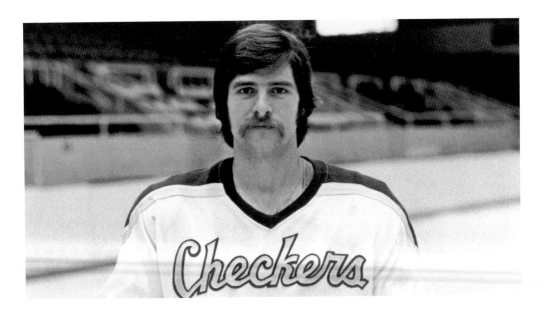

JEAN LANDRY (DEFENSE). He skated with Charlotte during the 1975–1976 championship year. Landry had 35 points, 23 assists, and 40 PIM in 57 games that season. The defenseman also played in the SHL with Roanoke Valley (1975–1976) and Tidewater (1976–1977). Landry spent two seasons in the AHL (1973–1975) and one season in the NAHL (1976–1977).

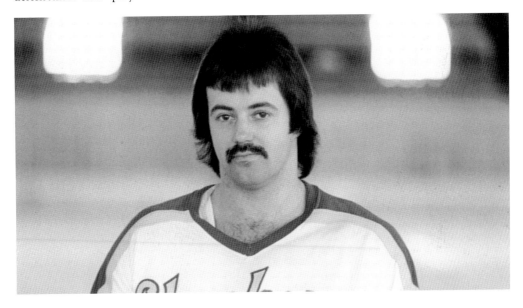

DAVE GILMOUR (LEFT WING). Gilmour played with Charlotte during their consecutive Crockett Cup championship seasons. The left winger had 48 points, 23 goals, and eight PIM in 40 games with the Checkers. Gilmour had a stint in the WHA (1975–1976) and also skated in the AHL (1970–1971 and 1973–1975) and the WHL (1972–1973).

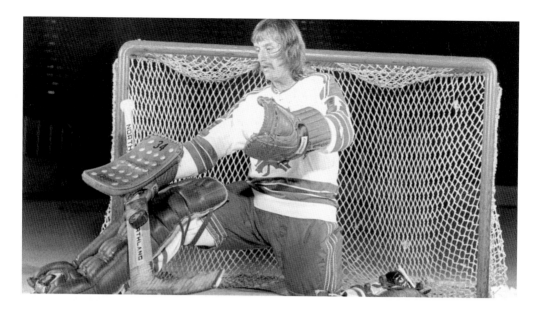

DANNY SULLIVAN (GOALIE). Sullivan was between the pipes for Charlotte in the inaugural season of the SHL (1973–1974). He had a 2.51 GAA, a 9-1-0 record, and two shutouts in 11 games with the Checkers that season. The net minder won a Crockett Cup with Roanoke Valley (SHL) in 1973–1974 and a Lockhart Cup with Philadelphia (NAHL) in 1975–1976. He had two stints in the WHA in 1972–1973 and 1973–1974.

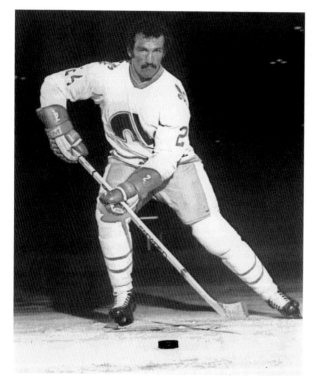

GILLES BILODEAU (LEFT WING). In his 1976–1977 season with Charlotte, Bilodeau had 242 PIM and nine points in 28 games. The left winger amassed 1,916 PIM in his professional hockey career, including 451 PIM in one regular season with Beauce, Quebec, of the NAHL in 1975–1976. Bilodeau spent four seasons in the WHA (1975–1979) and had 570 PIM and 22 points in 143 games. He had a stint in the NHL (1979–1980).

DALE MACLEISH (CENTER). MacLeish played part of the 1973–1974 SHL season in Charlotte and had 26 points, 12 goals, and 18 PIM in 22 games. He also played in the SHL with Roanoke Valley (1973–1974 and 1975–1976) and Suncoast (1973–1974). The center skated in one CHL season (1968–1969), four EHL seasons (1969–1973), and two NAHL seasons (1974–1976). MacLeish played for Lockhart Cup–winning Philadelphia (NAHL) in 1975–1976.

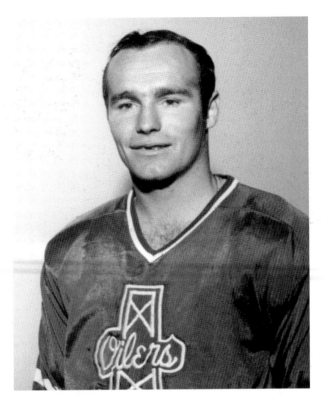

TONY CASSOLATO (RIGHT WING). The right winger had 19 points, 10 assists, and 18 PIM in 19 games with Charlotte (1976–1977). Cassolato played three seasons in the NHL (1979–1982) and had seven points, six assists, and four PIM in 23 games. During his time in the WHA (1976–1979), he had 88 points, 44 goals, and 147 PIM in 184 games. Cassolato won a Calder Cup (AHL) with Hershey (1979–1980).

GREG HICKEY (LEFT WING). Hickey had 13 points, 8 assists, and 4 PIM in 11 games with Charlotte in the 1976–1977 season. He also played in the SHL with Richmond (1976–1977) and spent six seasons in the AHL between 1975 and 1986, two seasons in the IHL (1975–1976 and 1979–1980), and one season in the ACHL (1982–1983). The left winger had a stint in the NHL in 1977–1978.

DEREK SMITH (CENTER). He had a stint with Charlotte in 1974–1975 and had seven points and four goals in four games. Smith is a veteran of eight NHL seasons (1975–1983). He produced 194 points and 116 assists in 335 NHL games. The center also spent time in the AHL (1974–1978 and 1982–1984).

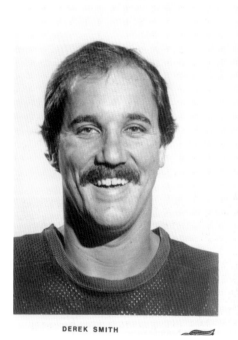

DEREK SMITH

GARRY MACMILLAN (RIGHT WING).
MacMillan played seven games with
Charlotte during the 1974–1975
championship season and had four
points, two goals, and 10 PIM. The
right winger also played in the SHL
with Greensboro (1974–1976), Winston-
Salem (1976–1977), and Richmond
(1976–1977). MacMillan skated for the
back-to-back Dayton (IHL) Turner Cup
teams in 1968–1969 and 1969–1970.

DOUG MAHOOD (RIGHT WING).
Mahood skated for Charlotte
in 1973–1974 and had 23
points, 15 assists, and 142 PIM
in 61 games. The right winger
played three seasons in the IHL
(1974–1977) and won a Turner
Cup with Toledo (1974–1975).

TERRY MARTIN (LEFT WING). Martin is a veteran of 10 NHL seasons (1975–1985). He had 205 points, 104 goals, and 202 PIM in 479 NHL games. The left winger was a member of Charlotte's 1975–1976 Crockett Cup team, and he collected 22 points, 12 goals, and 30 PIM in 25 games.

GARY WOOD (DEFENSE). A member of two Crockett Cup–winning teams with Charlotte in 1974–1975 and 1975–1976, Wood had 122 points, 104 assists, and 314 PIM in 225 games during his four seasons with the Checkers (1973–1977). He also skated in the SHL with Winston-Salem (1976–1977). The defenseman played part of his career in the IHL (1967–1968 and 1969–1971) and the EHL (1970–1973).

THE SOUTHERN LEAGUE

GAYE COOLEY (GOALIE).
Cooley had a 2.87 GAA and 16
shutouts in 181 games during
his five seasons with Charlotte
(1971–1972 and 1973–1977).
The net minder was a member
of three Checker championship
teams—1971–1972, 1974–1975,
and 1975–1976. He was the
leading goaltender in the SHL
in 1974–1975 and was named a
SHL all-star three times. Cooley
was in goal for Dayton's (IHL)
Turner Cup team in 1968–1969.

BOB SMULDERS (FORWARD).
Smulders played three seasons
with Charlotte (1974–1977)
and was a member of two
championship teams (1974–1975
and 1975–1976). He had 135
points, 47 goals, and 176 PIM in
165 games with the Checkers.
The forward also played in the
AHL (1973–1975).

HOCKEY IN CHARLOTTE

FRANK GOLEMBROSKY (RIGHT WING). Golembrosky played seven seasons with Charlotte (1968–1972 and 1973–1976) and was a member of four Checkers championship squads—two EHL (1970–1971 and 1971–1972) and two SHL (1974–1975 and 1975–1976). He accumulated 414 points, 257 assists, and 585 PIM in 337 games with Charlotte. Golembrosky played one season in the WHA (1972–1973) and had 20 points, 12 assists, and 53 PIM in 60 games.

BOB SAUVE (GOALIE). Sauve was between the pipes in 17 games for the 1975–1976 Crockett Cup champion Checkers, and he had a 2.21 GAA and two shutouts. In his 13-year NHL career from 1976–1989, the net minder had a 3.48 GAA and a 182-154-54 record, including eight shutouts in 420 games. Sauve also spent time in the AHL (1975–1979).

PERRY MILLER (DEFENSE). In his two seasons with the Checkers (1972–1974), he had 66 points, 51 assists, and 329 PIM in 131 games. A veteran of four NHL seasons (1977–1981), Miller accumulated 387 PIM and 61 points in 217 games. He skated in the WHA (1974–1977) and compiled 309 PIM, 90 points, and 59 assists in 201 games. Miller won a Calder Cup (AHL) with Adirondack in 1980–1981.

ANDRE DESCHAMPS (FORWARD). The forward played two seasons with Charlotte (1973–1975) and had 107 points, 63 goals, and 206 PIM in 80 games. Deschamps set the all-time SHL single-season goal mark (59) in 1974–1975, while he was a member of the Checkers' Crockett Cup team. He also played in the SHL with Tidewater in 1976–1977 and skated in the AHL (1973–1974 and 1975–1976) and NAHL (1976–1977).

NORM SCHMITZ (DEFENSE). Schmitz played nine games for the 1973–1974 Checkers and had four points on four assists. Schmitz won an Adams Cup with Oklahoma City (CPHL) in 1965–1966 and a Walker Cup with Syracuse (EHL) in 1972–1973. The defenseman also skated in the SHL with Macon (1973–1974) and Hampton (1975–1976). Schmitz spent most of his playing days in the EHL (1967–1973).

PAUL TANTARDINI (LEFT WING). Tantardini was a member of four Turner Cup (IHL) championship teams with Toledo (1974–1975, 1977–1978, 1981–1982, and 1982–1983). In his one season with Charlotte, in 1973–1974, the left winger had 25 points, 18 assists, and 121 PIM in 50 games. He also skated in the CHL (1975–1976) and the AHL (1978–1979).

DAN MANDRYK (RIGHT WING). In 1976–1977 with Charlotte, the right winger had 12 points and nine assists in 30 games. Mandryk also played three years in the CHL (1974–1977) with Tucson, Tulsa, and Oklahoma City.

JOHN HELD (DEFENSE). In his one season with the Checkers (1976–1977), Held had 11 points, 8 assists, and 44 PIM in 24 games. He also played in the SHL with Roanoke Valley (1975–1976) and spent a season in the CHL (1974–1975).

NORM COURNOYER (CENTER). In his only season with Charlotte (1976–1977), he had 44 points, 32 assists, and 14 PIM in 40 games. He spent two seasons in the WHA (1973–1974 and 1976–1977) and collected 11 points and seven assists in 32 games. The center won a Walker Cup with Syracuse (EHL) in 1972–1973 and a PHL championship with San Francisco (1977–1978).

JACK SURBEY (FORWARD). Surbey was a member of Charlotte's 1975–1976 Crockett Cup team. In his three seasons with the Checkers (1972–1973 and 1975–1977), the forward produced 133 points, 82 assists, and 321 PIM in 148 games. He won a Calder Cup with Cincinnati (AHL) in 1972–1973.

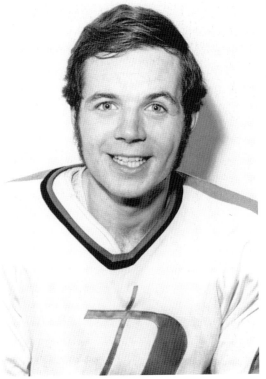

KEN SOUTHWICK (DEFENSE). The defenseman had four points, three assists, and 12 PIM in 13 games with Charlotte (1976–1977). Southwick also played in the SHL with Hampton (1974–1976) and Winston-Salem (1975–1977). He skated in the old EHL (1971–1972), AHL (1971–1973), IHL (1972–1973), NAHL (1973–1974), revived EHL (1980–1981), and ACHL (1982–1983).

ALLIE SUTHERLAND (LEFT WING). He had 231 points, 127 goals, and 398 PIM in 239 games during his four seasons with the Checkers (1968–1972). Besides winning two playoff championships with Charlotte, he was also a member of Adams Cup (CHL in Omaha in 1972–1973) and Lockhart Cup (NAHL in Syracuse in 1976–1977) championship teams. Sutherland played two seasons in the SHL with Greensboro (1975–1977).

KEN REID (DEFENSE). Reid skated three seasons with Charlotte (1973–1975 and 1976–1977). He totaled 50 points, 40 assists, and 159 PIM in 128 games with the Checkers. He was a member of Charlotte's Crockett Cup championship team in 1974–1975. Reid also played in the SHL with Greensboro (1975–1976).

THE SOUTHERN HOCKEY LEAGUE

NEIL KORZACK (FORWARD).
Korzack was a member of the
Checkers during their two SHL
playoff championship seasons
in 1974–1975 and 1975–1976.
He had 143 points, 75 goals,
and 114 PIM in 137 games
with Charlotte. The forward
also skated in the AHL for two
seasons (1973–1975).

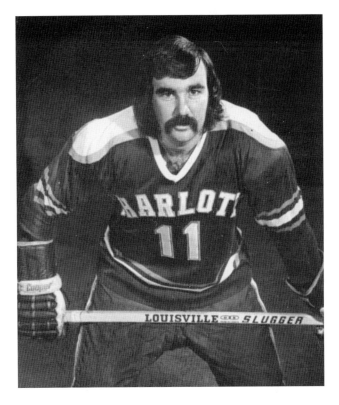

DAVE BIRCH (LEFT WING). The
left winger had 62 points, 36
goals, and 146 PIM in 69 games
with Charlotte (1973–1974).
Birch played most of his career
with Johnstown (1970–1973
and 1975–1977) in the EHL and
NAHL. He also skated in the
IHL for one season (1974–1975).

RICK JODZIO (LEFT WING). He played with Charlotte during the 1974–1975 Crockett Cup season and had 109 PIM, 17 points, and 9 goals in 37 games. Jodzio skated in the WHA for three seasons (1974–1977) and collected 31 points, 15 goals, and 257 PIM in 137 games. The left winger also played in the SHL with Tidewater (1976–1977) and spent time in the AHL (1975–1976 and 1979–1980) and CHL (1978–1979).

BOB GIRARD (FORWARD). A veteran of five NHL seasons (1975–1980), Girard had 114 points, 45 goals, and 140 PIM in 305 games. The forward had 22 points, 17 assists, and 12 PIM in 23 games with Charlotte in 1973–1974. He won a Patrick Cup with Salt Lake City (WHL) in 1974–1975 and a Calder Cup with Hershey (AHL) in 1979–1980.

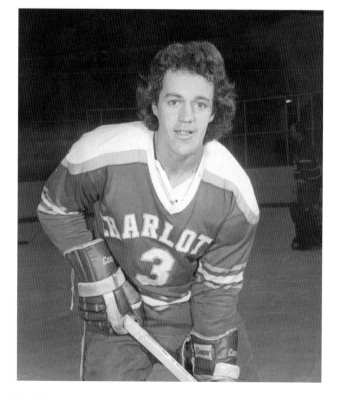

THE SOUTHERN HOCKEY LEAGUE

LORNE ROMBOUGH (LEFT WING). He skated for one season with Charlotte (1976–1977) and earned 45 points, 30 goals, and 20 PIM in 49 games. Rombough also played two seasons in the SHL with Hampton (1974–1976). The left winger had a stint in the WHA with Chicago (1973–1974) and spent time in the IHL (1968–1971 and 1972–1973), old EHL (1970–1972), AHL (1972–1973), NAHL (1973–1974), and NEHL/EHL (1978–1980).

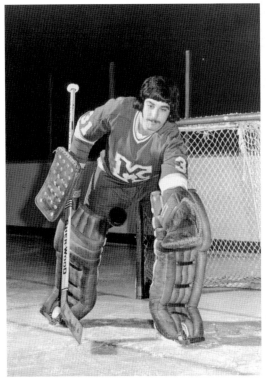

DON MUIO (GOALIE). Muio was between the pipes for Charlotte's 1974–1975 championship team. Muio had a 3.78 GAA and one shutout in 27 games that season. The net minder also played in the CHL (1973–1974) and in the IHL (1974–1975).

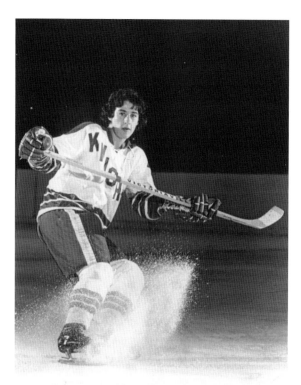

JOHN MARTIN (CENTER). Martin had a stint with the Checkers during the 1973–1974 season and had five PIM in three games. Martin played in the AHL (1972–1973), CHL (1972–1973 and 1975–1977), and IHL (1973–1975). The center won two Turner Cups (IHL) with Des Moines in 1973–1974 and Toledo in 1974–1975 and one Adams Cup with Omaha (CHL) in 1972–1973.

DAVE TATARYN (GOALIE). He had a 2.99 GAA in 39 games with the Checkers during the 1976–1977 season. Tataryn was in net for 23 games in the WHA with Toronto (1975–1976) and compiled a 4.76 GAA and a 7-12-1 record. The net minder also spent time in the NAHL (1975–1977), the IHL (1975–1976), and the AHL (1976–1977). He made a brief appearance in the NHL in 1976–1977 and had a 7.50 GAA in two games.

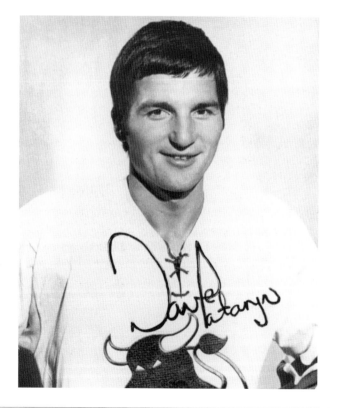

6

PROFESSIONAL HOCKEY
RETURNS TO CHARLOTTE

Professional hockey returned to Charlotte in 1993–1994 after a 15-year hiatus. Charlotte was granted an expansion franchise in the East Coast Hockey League (ECHL), a league that was founded in 1988–1989. Former Charlotte coach Pat Kelly was commissioner of the ECHL from the loop's first season. The team was nicknamed the Checkers, a name that was synonymous with Charlotte hockey in the past. John Marks was named coach of the team and would pilot the Checkers through 1997–1998. The Checkers made the playoffs in the team's inaugural campaign with a 39-25-4 record and a fourth-place finish in its division. Sergei Berdnikov's 48 regular-season goals in 1993–1994 set the all-time single-season team record. In the postseason, Charlotte renewed its old rivalry with Greensboro (a team named the Monarchs that joined the league in 1989–1990) and faced the squad in the first round of the playoffs. The Monarchs beat the Checkers two games to one.

The following season, Charlotte improved to third place in its division with a 37-22-9 record. The locals, however, were swept in three straight in the first round against Greensboro.

In 1995–1996, the Charlotte Checkers won the ECHL's playoff championship and were awarded the Jack Riley Cup. The locals finished with a 45-21-4 record in second place in their division and achieved their highest win total (45) and point total (94) in franchise history. In the postseason, the Checkers won 13 of 16 games on their way to the ECHL title. The locals swept the Roanoke Express in three straight games and edged the South Carolina Stingrays three games to two during the first two rounds. In the semifinals, Charlotte tamed the Tallahassee Tiger Sharks three games to one and then swept the Jacksonville Lizard Kings in four straight games to capture the championship. Charles Paquette (defense) was named to the ECHL's all-rookie team.

The Checkers were the last team to win the Jack Riley Cup, because the trophy was retired after the season was over. Riley, one of the most respected names in hockey, was successful as a player, coach, general manager, and scout. He was AHL president from 1964 to 1966, SHL commissioner from 1974 to 1977, and IHL commissioner from 1979 to 1983.

The Riley Cup was replaced by the Patrick J. Kelly Cup as the ECHL playoff championship trophy. The Kelly Cup was named in honor of the ECHL's only commissioner and a league founder who retired after the 1995–1996 season. Mr. Kelly was also given the title commissioner emeritus.

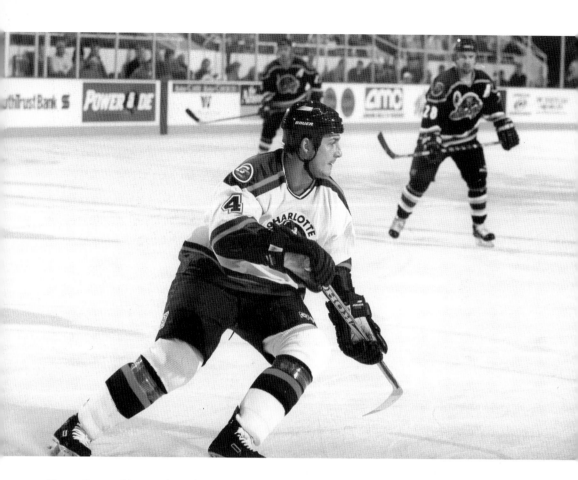

KURT SEHER (DEFENSE). Seher played more games (593) and more seasons (10) in a Checkers uniform than any other player. The defenseman is third all time in points (276) and assists (203) and is tied for the second-most PIM (527) in franchise history. He also netted 73 goals during his years in Charlotte (1993–2003). Seher was a member of the Checkers' 1995–1996 Riley Cup championship team.

ERIC FENTON (RIGHT WING). The right winger amassed 468 PIM, 64 points, and 36 assists in 91 games during his three seasons with the Checkers (1994–1997). Fenton skated for Charlotte's 1995–1996 Riley Cup–winning team and won a Calder Cup with Portland (AHL) in 1993–1994. He also played in the ECHL with Hampton Roads (1993–1994) and spent six seasons in the IHL (1994–2000).

ANDRE BASHKIROV (RIGHT WING). In his two seasons with the Checkers (1993–1995), the Bashkirov garnered 116 points, 47 goals, and 45 PIM in 123 games. A veteran of three NHL seasons (1998–2001), Bashkirov had three points in 30 games. He also played in the ECHL with Huntington (1995–1997). Bashkirov spent time in the AHL (1993–1994 and 1998–2001) and the IHL (1996–1999).

DARRYL NOREN (CENTER). Noren is the Checkers' all-time leader in points (403), goals (174), and assists (229). He also played the second most games (365) in franchise history. The center spent six years with Charlotte (1994–2000) and was a member of the Riley Cup–winning team of 1995–1996. He served as player/assistant coach of the Checkers in 1999–2000.

ROB TALLAS (GOALIE). In 36 games with Charlotte (1994–1995), he had a 3.40 GAA and a 21-9-3 record. Tallas is a veteran of six NHL seasons with Boston (1995–2000) and Chicago (2000–2001). He had a 2.91 GAA and a 28-42-10 record in 99 NHL games. The net minder also played seven seasons in the AHL (1994–1998 and 2000–2003).

SERGEI BERDNIKOV (LEFT WING). The left winger had 161 points, 85 goals, and 105 PIM in 110 games during his two seasons with Charlotte (1993–1995). Berdnikov was in the AHL for one season in 1993–1994 and played most of his career in Russia (1990–1994 and 1995–2005).

SCOTT MEEHAN (DEFENSE). Meehan (#12) was a member of the Checkers' Riley Cup championship team in 1995–1996. The defenseman amassed 326 PIM, 45 points, and 35 assists in 174 games during his three seasons in Charlotte (1993–1996). He spent one season in the AHL (1993–1994). Meehan played college hockey with the University of Lowell (later University of Massachusetts at Lowell) from 1989 to 1993.

REGGIE BREZEAULT (CENTER). In his three seasons with Charlotte (1994–1995 and 1998–2000), Brezeault had 144 PIM, eight points, and five goals in 44 games. He also played in the ECHL with Roanoke (1993–1995), Birmingham (1995–1996), and Louisville (1995–1996). The center was a member of Sunshine Trophy–winning West Palm Beach of the Sunshine Hockey League in 1994–1995. Brezeault spent time in the CHL in 1993–1994 and 1996–1997 and the Colonial Hockey League (CoHL) in 1996–1997.

J. F. AUBE (RIGHT WING). He had 224 points, 140 assists, and 68 PIM in 186 games during his three seasons with Charlotte (1995–1997 and 1998–1999). The right winger was a member of the Checkers' 1995–1996 Riley Cup championship team. He also skated in the ECHL with Pensacola (1997–1998) and Mississippi (1999–2001).

1993–1994 CHECKERS INAUGURAL SEASON PROGRAM. Professional hockey returned to Charlotte after a 15-year hiatus when the East Coast Hockey League awarded the city an expansion team. Sergei Berdnikov's 48 goals in 1993–1994 remains a Checker single-season record. Berdnikov, who did not skate in 20 of Charlotte's games that season, scored the 48 goals in 48 games.

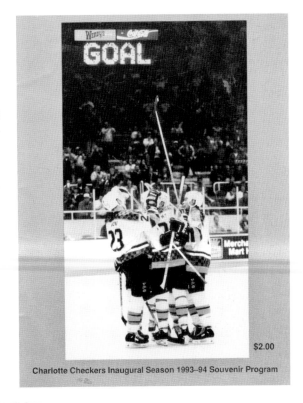

Charlotte Checkers Inaugural Season 1993–94 Souvenir Program

HOWIE ROSENBLATT (RIGHT WING). In his two seasons with Charlotte (1993–1995), the right winger accumulated 211 PIM, 40 points, and 22 goals in 49 games. He also played in the ECHL with five other teams from 1991 to 1996. Rosenblatt won two Colonial Cup championships with Quad City of Iowa (CoHL/United Hockey League) in 1996–1997 and 1997–1998. He had experience in the AHL between 1991 and 1998.

1994–1995 Season

OFFICIAL GAME PROGRAM

CHARLOTTE CHECKERS

1994–1995 CHECKERS PROGRAM. During the 1994–1995 season, Matt Robbins proved that his 1993–1994 performance with Charlotte was no fluke. Robbins, who led the Checkers in scoring in the team's inaugural campaign with 89 points, also led the club in scoring in 1994–1995 by tallying 89 points. The center is the only Charlotte player to lead the team in scoring in back-to-back seasons. All four pictures on the program cover are of Robbins.

1995–1996 CHECKERS PROGRAM. The Checkers won the ECHL's Riley Cup title in 1995–1996 and gave the city of Charlotte its sixth professional hockey championship. The championship was also significant in that it gave Charlotte the distinction of winning a playoff championship in every league that the city was a member of—the ECHL, the SHL, and the EHL.

Center Of The Action

Checkers Career Points Leader Matt Robbins

1995-1996 Official Game Program

7

THE WINNING TRADITION
IN CHARLOTTE CONTINUES

The Checkers had a 35-28-7 record in 1996–1997 (fifth place in their division) and secured a playoff spot. The locals' quest for a second straight championship was short lived, as they were eliminated in the first round of the postseason in three straight games against the South Carolina Stingrays.

Charlotte achieved their fifth consecutive winning season in their five-year existence in 1997–1998 with a 35-24-11 second-place finish in their division. They beat the Birmingham Bulls in the first round of the playoffs three games to one. In the conference semifinals they dropped three straight games to the Pensacola Ice Pilots.

Over the next two campaigns, the Checkers experienced losing seasons. The locals had a 29-30-11 record and a sixth-place finish in their division in 1998–1999 and a 25-38-7 record and a fifth-place finish in their division in 1999-2000. Charlotte did not make the playoffs in either season. Shawn Wheeler piloted the team in 1998–1999 and was replaced midseason in 1999–2000 by Don MacAdam.

The team got back their winning ways under MacAdam in 2000–2001 with a 34-26-12 record and a third-place finish in their division. The club had an early exit in the postseason, losing in the first round to the Dayton Bombers three games to two. ECHL leading scorer Scott King (center) was named ECHL Most Valuable Player and became the Checkers' first ECHL all-star ever (named to the second team) that season. Charlotte's Mathieu Benoit (forward) received ECHL all-rookie team honors in 2000–2001.

The following season, the Checkers improved to 41-20-11 and a second place finish in their division but were edged out in the first round of the playoffs by the Atlantic City Boardwalk Bullies three games to two. Charlotte had three players named to the ECHL's all-star squad in 2001–2002: Brandon Dietrich (left wing) to the first team and Dave Duerden (left wing) and Justin Harney (defense) to the second team.

In 2002–2003, the Checkers had a 41-28-3 record but astoundingly missed the playoffs by one point due to a very competitive division. The locals finished in fifth place and the top four teams in each division moved on to the postseason. The following year, in 2003–2004, MacAdam was replaced midseason by Derek Wilkinson. The club slipped below the .500 regular season mark with a 31-32-9 record, and at sixth place in its division, did not qualify for the postseason.

In 2004–2005, Charlotte was back in the playoffs with a 39-26-7 record, finishing seventh out of 10 teams in the realigned ECHL. The Checkers had their best postseason since their 1995–1996 championship, making it all the way to the conference finals and only two games away from the Kelly Cup finals. In the conference quarterfinals, the locals defeated the Columbia Inferno in three straight games. After losing game one of the conference semifinals, Wilkinson's team won three in a row over the Gwinnett (Georgia) Gladiators to advance. In the conference finals, Charlotte lost to the Florida Everblades in six games.

During the team's first 12 seasons, the Checkers have been one of the most successful franchises in the ECHL.

LEE HAMILTON (DEFENSE). The defenseman played three seasons with the Checkers (1999–2002) and collected 201 PIM, 21 points, and 16 assists in 110 games. Prior to coming to Charlotte, Hamilton had stops in three ECHL cities—Birmingham (1997–1998), Columbus (1998–1999), and Baton Rouge (1998–1999). He started his professional career in the CHL with Oklahoma City in 1997–1998.

BRYCE WANDLER (GOALIE). In his three seasons in Charlotte from 2000 to 2003, Wandler had a 3.23 GAA and an 18-11-6 record in 43 games. He also was between the pipes in the ECHL with Lexington in 2002–2003 and spent time in the United Hockey League (UHL) in 2000–2001, the AHL from 2000–2002, and the CHL in 2002–2003.

MIKE HARTMAN (LEFT WING). A veteran of nine NHL seasons (1986–1995) with Buffalo, the Rangers, Tampa Bay, and Winnipeg. Hartman amassed 1,388 PIM and 78 points in 397 NHL games. The left winger won a Stanley Cup with the Rangers in 1993–1994. In four seasons with Charlotte (1997–1998, 2000–2001, and 2002–2004), he had 65 points, 38 goals, and 120 PIM in 109 games. Hartman skated for Calder Cup–winning Hershey (AHL) in 1996–1997.

SCOTT KING (CENTER). King was the most valuable player of the ECHL in 2000–2001 while playing for Charlotte. The center was selected as a second-team ECHL all-star, set the Checkers' all-time single-season record for points (101), and tied the all-time team single-season record for assists (61) in 2000–2001. He also had 40 goals and 34 PIM in 72 games with Charlotte that season.

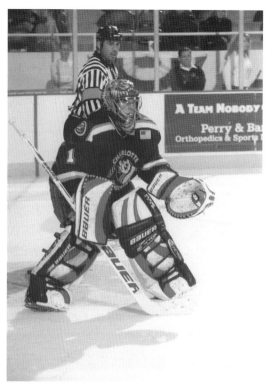

SCOTT MEYER (GOALIE). Meyer holds all-time Checkers' records for career GAA (2.58), shutouts (six), and games played in goal (89). The net minder played three seasons with Charlotte (2001–2004) and compiled a 49-26-7 record. He spent two seasons in the AHL (2001–2003) and played college hockey with St. Cloud State (1996–2001).

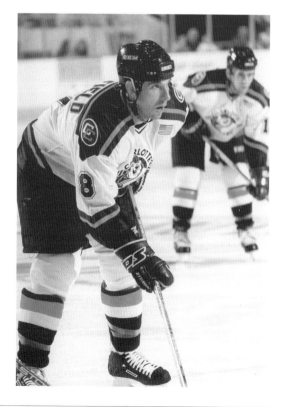

KEVIN CAULFIELD (FORWARD). In three seasons with Charlotte (2001–2004), the forward had 102 points, 55 assists, and 209 PIM in 140 games. Caulfield also skated in the ECHL with Wheeling (2000–2001) and played in the UHL (2001–2002) and the AHL (2002–2003).

PAXTON SCHAFER (GOALIE). He had a 2.98 GAA and a 24-18-5 record in 48 games during his two seasons with the Checkers from 1996 to 1998. The net minder went on to play five more years in the ECHL (1998–2003) and spent time in the AHL (1996–1999 and 2000–2001) and the UHL (2002–2003). He had a stint in the NHL with Boston in 1996–1997, compiling a 4.68 GAA in three games.

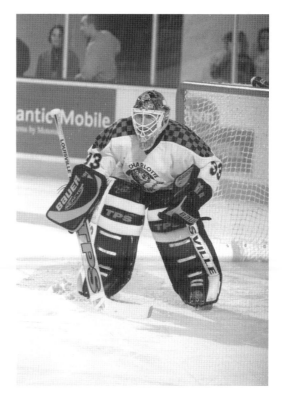

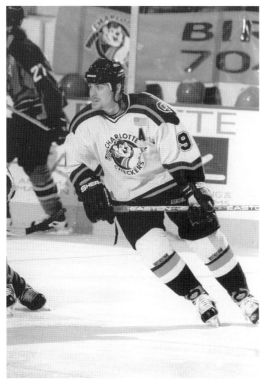

KEVIN HILTON (CENTER). Hilton produced 202 points, 140 assists, and 126 PIM in 202 games in his three seasons with the Checkers (1999–2002). The center also played in the ECHL with Mississippi (1996–1997 and 1998–1999) and Mobile (1997–1998), winning a Kelly Cup with the Mississippi Sea Wolves in 1998–1999. He spent time in the IHL from 1996 to 1998, AHL between 1996 and 2002, and the Western Professional Hockey League (WPHL) in 1998–1999.

HOCKEY IN CHARLOTTE

NICHOLAS BILOTTO (DEFENSE). He accumulated 323 PIM, 103 points, and 76 assists in 163 games during his three seasons with the Checkers (2001–2004). Bilotto also played in the ECHL with Mississippi (2003–2004) and had stops in the UHL (2000–2001 and 2004–2005) and the AHL (2002–2005).

JASON LABARBERA (GOALIE). He compiled a 2.97 GAA and a 27-13-8 record in 48 games during his two seasons with the Checkers (2000–2002). Labarbera had two stints in the NHL with the Rangers (2000–2001 and 2003–2004) and had a 4.62 GAA and a 1-2-0 record in five games. The net minder also saw action in the AHL (2000–2005).

MARC TROPPER (RIGHT WING). Tropper had 115 points, 47 goals, and 161 PIM in 116 games during his two seasons with Charlotte (1999–2001). He also skated in the ECHL with Chesapeake (1998–1999), Greensboro (1999–2000), and Jackson (2002–2003). The right winger was a member of the Canadian National Team in 1999–2000.

DALE PURINTON (DEFENSE). Purinton is a veteran of five NHL seasons with the Rangers (1999–2004). He accumulated 578 PIM, 20 points, and 16 assists in 181 NHL games. In his only season with Charlotte (1997–1998), the defenseman had 186 PIM, eight points, and five assists in 34 games. He won a Calder Cup with Hartford (AHL) in 1999–2000.

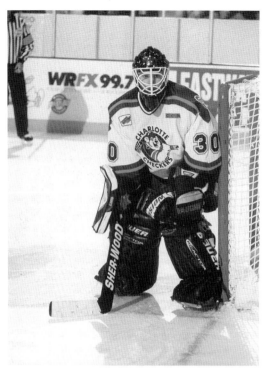

TARAS LENDZYK (GOALIE). In his two seasons between the pipes for Charlotte (1998–2000), Lendzyk compiled a 3.39 GAA and an 18-18-7 record in 48 games. The net minder won a Kelly Cup with South Carolina (ECHL) in 1996–1997. He played college hockey with the University of Minnesota at Duluth from 1992 to 1996.

SHAWN WHEELER (LEFT WING). Wheeler piloted the Checkers from 1998 to 2000 and compiled a 43-48-14 (.476) regular season record. Wheeler also served as player/assistant coach for two seasons with Charlotte (1994–1996) and assistant coach for one season (1996–1997). The left winger accumulated 476 PIM, 143 points, and 68 goals in 138 games with the Checkers. He was a member of the Checkers' 1995–1996 Riley Cup team.

DAVID OLIVER (FORWARD). He amassed 390 PIM, 72 points, and 32 goals in 125 games during his two seasons in Charlotte (2000–2002). Oliver also played in the ECHL with Huntington (1999–2000). The forward spent time in the WPHL (1998–1999), the AHL (1998–2000), and the CHL (2002–2005).

BILL MCCAULEY (DEFENSE). The defenseman had 72 points, 54 assists, and 97 PIM in 96 games with Charlotte from 1996 to 1998. He also played in the ECHL with Greenville (1998–2000) and Dayton (2000–2003) and spent time in the AHL (1995–1998 and 2001–2002).

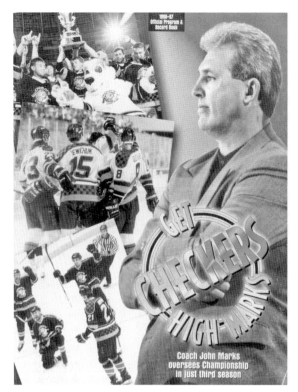

1996–1997 CHECKERS PROGRAM. The program cover features coach John Marks (right) and the Checkers celebrating during the club's 1995–1996 Riley Cup championship season. Marks piloted Charlotte for five seasons (1993–1998), compiling a 191-120-35 (.603) regular season record. In each of his seasons as coach, the Checkers had a winning regular-season record and qualified for the playoffs.

1997–1998 CHECKERS PROGRAM FEATURING MIKE HARTMAN. Hartman was in his first season with Charlotte in 1997–1998 and brought nine years of NHL experience with him to the ECHL club. The left winger tallied 30 goals and 48 points for the Checkers that season.

1997–1998 CHECKERS PROGRAM FEATURING DARRYL NOREN. Noren is the Checkers' all-time leader in all three offensive categories—points (403), goals (174), and assists (229). In 1997–1998, the center was second on the team in scoring with 76 points from 26 goals and 50 assists.

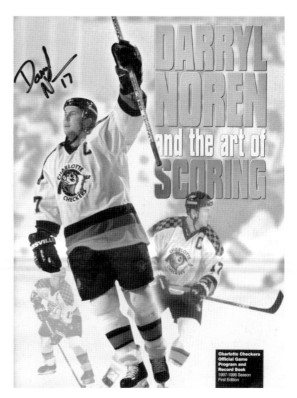

1998–1999 CHECKERS PROGRAM FEATURING COACH SHAWN WHEELER. Wheeler was Charlotte's new coach in 1998–1999. He piloted the team to a 29-30-11 record and just missed making the playoffs. The former Checker player was also behind the bench with Charlotte for part of the 1999–2000 season and compiled an overall regular season record of 43-48-14 (.476) in his two seasons with the club.

TYLER DEIS (RIGHT WING). In his two seasons with the Checkers (1999–2001), Deis had 55 points, 24 goals, and 250 PIM in 114 games. After skating for Charlotte, the right winger toured five other ECHL cities—Baton Rouge (2001–2002), Mobile (2001–2002), Greenville (2002–2004), Cincinnati (2003–2004), and Gwinnett (2003–2004). He also played in the CHL (2003–2004).

KONRAD MCKAY (CENTER). McKay accumulated 589 PIM, 119 points, and 43 goals in 170 games during three seasons with the Checkers (2001–2004). He skated in the WPHL (2000–2001), the AHL (2001–2003), and the CHL (2004–2005).

ANTTI LAAKSONEN (LEFT WING). The left winger is a veteran of six NHL seasons (1998–2004) with Boston and Minnesota. He had 130 points, 62 goals, and 96 PIM in 361 NHL games. Laaksonen played in the AHL (1997–2000) and won a Calder Cup with Providence in 1998–1999. In his only season with the Checkers (1997–1998), he had seven points, four goals, and 12 PIM in 15 games.

ERIC BOULTON (LEFT WING). Boulton amassed 527 PIM, 52 points, and 25 goals in 97 games during his two seasons in Charlotte (1996–1998). He is a veteran of four NHL seasons with Buffalo (2000–2004) and compiled 511 PIM, 17 points, and 12 assists in 172 games. The left winger also skated in the ECHL with Florida (1998–1999) and Columbia (2004–2005). He played for Turner Cup–winning Houston (IHL) in 1998–1999.

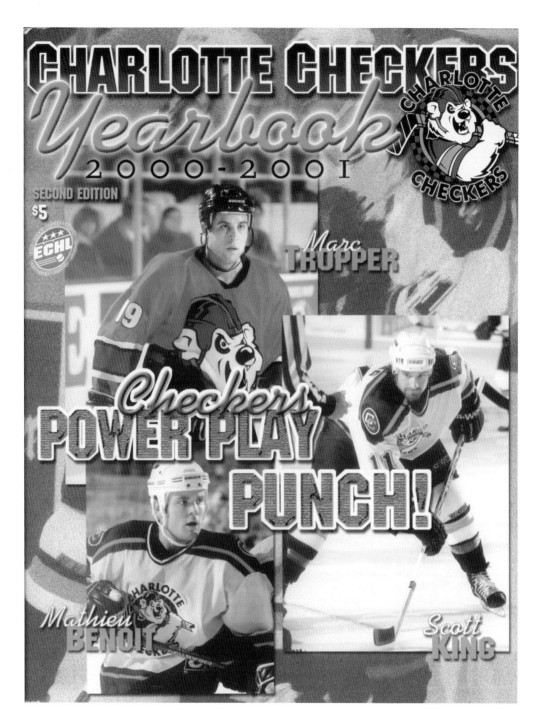

2000–2001 CHECKERS YEARBOOK. During the 2000–2001 season, Scott King became the only ECHL Most Valuable Player and ECHL leading scorer in Charlotte Checkers history. King also became the Checkers' first ECHL all-star ever, being named to the second team.

8

PATRICK J. KELLY

A HOCKEY LEGEND

Patrick J. Kelly (known as Pat Kelly) is perhaps the most well-rounded individual in the history of minor-league professional hockey. He was successful as a player, player/coach, bench coach, general manager, and commissioner, and he even had a league playoff championship trophy named in his honor. There has never been an individual in minor-league hockey history that could boast such a resume as Pat Kelly.

As a player, he was a member of four championship teams in the Eastern Hockey League (EHL)—one as a full-time player with the Greensboro Generals (1962–1963) and three as a player/coach with the Clinton Comets (1967–1968 to 1969–1970). The defenseman started his professional hockey career in the Quebec Hockey League (QHL) in 1957–1958 with Trois Rivieres and then split the following year between Trois Rivieres (QHL) and Troy of the International Hockey League (IHL). Kelly began the first of his 14 seasons in the EHL with Greensboro and New Haven in 1959–1960. He gained his first head coaching job in 1964–1965 with the EHL's New Jersey Devils as a player/coach. In 1967–1968, the player/coach guided the Clinton Comets (EHL) to the greatest regular season in the history of minor-league professional hockey with a 57-5-10 record (.861). It was the first of his three consecutive playoff championships with the Comets. He ranks fourth in assists (619), seventh in games played (835), and ninth in PIM (1,150) on the EHL's all-time lists and was selected to the EHL all-star team a record nine times. His minor-league regular season player totals are: 757 points, 664 assists, 93 goals, and 1,359 PIM in 946 games.

Kelly coached nine teams in eight different professional hockey leagues, including the National Hockey League (NHL) and the World Hockey Association (WHA). He guided his teams to six playoff championships, seven regular-season titles, and eight division titles. The six playoff titles were in three different leagues—three Walker Cups with Clinton (EHL), two Crockett Cups with Charlotte (SHL), and one Turner Cup with Peoria (IHL). He also coached in the American Hockey League (AHL), the revived Eastern Hockey League (EHL), and the Atlantic Coast Hockey League (ACHL). In the NHL, he piloted the Colorado Rockies to their only Stanley Cup playoff appearance in team history during his first of two seasons with the club (1977–1979), compiling a 22-54-25 (.342) NHL regular season record. In 1976–1977, he led the Birmingham Bulls (WHA) to a 24-30-3 (.447) regular season record. Kelly received several honors throughout his coaching career: he was voted to the EHL all-star team as a coach three times; in 1969–1970, he was named the *Hockey News* Minor League Hockey Coach of the Year; he shared SHL coach of the year honors in 1974–1975; and he shared the IHL's Commissioner's Trophy as coach of the year in 1984–1985. Kelly's overall regular-season coaching record was 835-712-160 (.536).

As commissioner of the East Coast Hockey League (ECHL) during the loop's first eight seasons, Kelly helped expand the game of hockey into new markets and developed a five-team circuit into the biggest minor professional hockey league in North America. The hockey legend brought professional hockey to Huntsville, Alabama; Huntington, West Virginia; Lafayette, Louisiana; Mobile, Alabama; Raleigh, North Carolina; Charleston, South Carolina; and Tallahassee, Florida. When Kelly stepped down as ECHL commissioner at the end of the 1995–1996 season, the ECHL Board of Governors instituted a new ECHL playoff championship trophy—the Kelly Cup—in honor of his accomplishments with the league. The board also gave Kelly the title of commissioner emeritus.

Kelly has been inducted into four sports halls of fame. He was enshrined into the Peoria Sports Hall of Fame in February 1990. The Roanoke Hall of Fame and the Sports Hall of Fame in his hometown of Welland, Ontario, elected him in 1998. In March 2002, Kelly became the first inductee into the Greensboro Hockey Hall of Fame when the Generals (ECHL) retired his uniform, number five.

As a player, player/coach, bench coach, general manager, commissioner, or commissioner emeritus, Patrick J. Kelly is a hockey man of many titles and is truly a hockey legend.

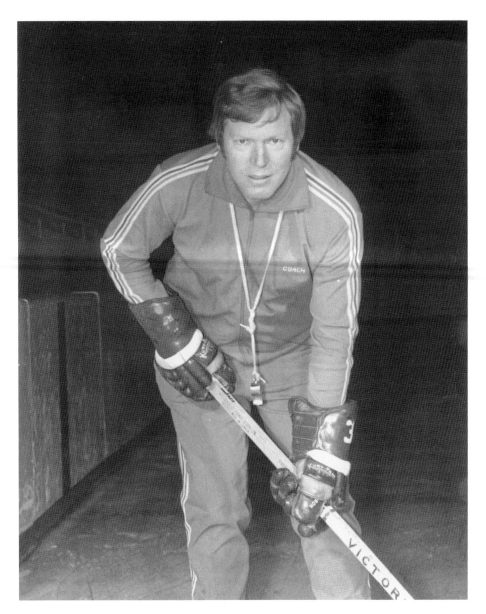

PAT KELLY (PLAYER/COACH). One of the greatest coaches in minor-league history is pictured here. Kelly piloted Charlotte during all four of their SHL seasons. He had a 146-75-12 (.652) regular-season record with the Checkers and led them to two playoff and two regular-season championships. Kelly won a total of six minor-league professional championships. Besides the SHL, he guided Clinton (EHL) to three consecutive Walker Cups (1967–1968, 1968–1969, and 1969–1970) and Peoria (IHL) to a Turner Cup title (1984–1985). The *Hockey News* selected him Minor League Coach of the Year for 1969–1970. The defenseman coached in the WHA with Birmingham (1976–1977) and in the NHL with Colorado (1977–1979). His professional regular-season player totals are: 757 points, 664 assists, 93 goals, and 1,359 PIM in 946 games.

HOCKEY IN CHARLOTTE

PAT KELLY WITH THE ECHL'S KELLY CUP. When Kelly stepped down as ECHL commissioner at the end of the 1995–1996 season, after serving that office for eight campaigns, the ECHL Board of Governors instituted a new ECHL playoff championship trophy—the Kelly Cup—in honor of his accomplishments with the league. The board also gave Kelly the title of commissioner emeritus.

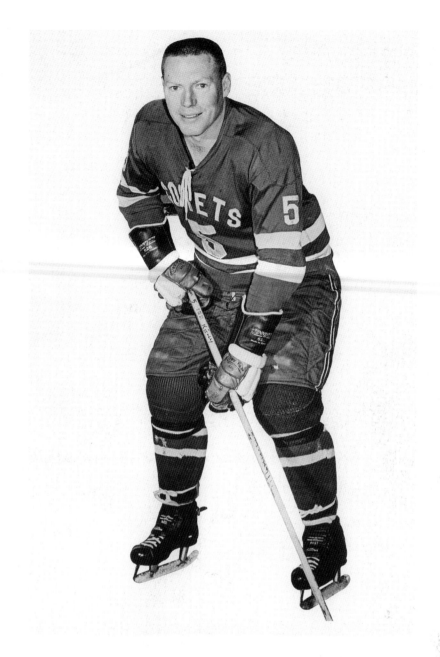

PAT KELLY IN HIS CLINTON UNIFORM (DEFENSE). Kelly is one of the greatest players to ever play in the 40-year history of the Eastern Hockey League and is also one of the greatest players in the history of minor-league hockey. He was a well-rounded player in terms of leadership, scoring ability, defensive ability, and toughness. Pat Kelly was player/coach of arguably the greatest minor-league hockey team of all-time—the 1967–1968 Clinton Comets (EHL). The Comets had the highest regular season winning percentage of any minor-league team: .861 with a 57-5-10 record. The Comets also won the EHL's Walker Cup playoff championship that season.

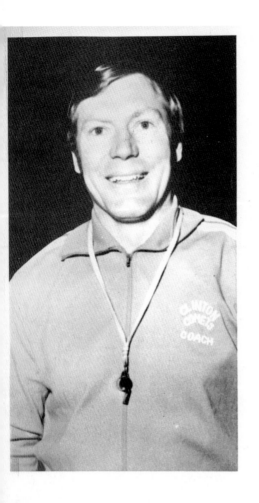

PAT KELLY
Testimonial
Dinner

Friday,
June 9, 1978
7:00 p.m.

Trinkaus
Manor

Sponsored by:
THE UTICA MOHAWKS

HOCKEY MAN OF THE YEAR. Pat Kelly was named Hockey Man of the Year by the Utica Mohawks Hockey Club (NEHL) for the 1977–1978 season. A ceremonial dinner was held on June 9, 1978, in Oriskany, New York, honoring Kelly. Kelly had just completed his first full season as coach of the NHL's Colorado Rockies, guiding them to their first playoff appearance. Several former teammates and players of the honoree as well as some old EHL opponents were among the 200 people that attended the dinner.